RAME PENINSULA
THROUGH TIME
Derek Tait

AMBERLEY PUBLISHING

Acknowledgements

Photograph credits: The Derek Tait Picture Collection, The Earl of Mount Edgcumbe Collection, Maurice Dart and Steve Johnson. Thanks also to Tina Cole and Tilly Barker.

I have tried to track down the copyright owners of all the older photographs used and apologise to anyone who hasn't been mentioned.

Check out my website at www.derektait.co.uk

Bibliography

Books:
Images of England: Plymouth, Derek Tait (Tempus 2003).
Plymouth at War, Derek Tait (Tempus 2006).
Mount Edgcumbe, Derek Tait (Driftwood Coast 2009).

Websites:
Cyberheritage at http://www.cyber-heritage.co.uk/
Derek Tait's Plymouth Local History Blog at http://plymouthlocalhistory.blogspot.com/

Newspapers:
The Evening Herald
The Western Morning News

First published 2010

Amberley Publishing
Cirencester Road, Chalford,
Stroud, Gloucestershire, GL6 8PE

www.amberleybooks.com

Copyright © Derek Tait, 2010

The right of Derek Tait to be identified as the Author of this work has been asserted in accordance with the Copyrights, Designs and Patents Act 1988.

ISBN 978-84868-610-6

British Library Cataloguing in Publication Data.
A catalogue record for this book is available from the British Library.

Typeset in 9.5pt on 12pt Celeste.
Typesetting by Amberley Publishing.
Printed in the UK.

Introduction

The Rame Peninsula covers a beautiful part of Cornwall. Known as the Forgotten Corner, it is quite often bypassed by people as they travel further down into other parts of the county. Included within the area is the magnificent Mount Edgcumbe Estate, with its beautiful gardens, deer park and unusual follies. In 1493, Sir Piers Edgcumbe married Joan Durnford and her dowry included land on both sides of the Tamar. In 1515, King Henry VIII granted Piers permission to empark deer on the land now known as Mount Edgcumbe and between 1547 and 1553, Sir Richard Edgcumbe of Cotehele added a new home to the deer park.

The estate has seen many changes over the years, with the adding of ornate buildings, statues and follies. Mount Edgcumbe House was bombed in 1941 and remained a shell for many years. Also, during the Second World War, the American troops left nearby at Barn Pool for D-Day in 1944.

Villages within the Peninsula include Cawsand, Kingsand, Millbrook, St John and Crafthole.

The villages of Cawsand and Kingsand were once the homes to fishermen and smugglers. Walking through the narrow streets today is almost like stepping back in time. Many of the buildings remain the same although most are now refurbished and used as holiday homes. Most of the fishermen and all of the smugglers left a very long time ago. A young sailor from Cawsand, Lieutenant John Pollard, was a midshipman onboard HMS *Victory* when Nelson was fatally wounded. Although not a well known name now, it was Pollard who shot and killed the enemy sailor who shot Nelson. He was known thereafter as, 'Nelson's Avenger'.

The beautiful coastline takes you along Whitsand Bay to the almost eerie Rame Head where the fourteenth-century St Michael's Chapel stands alone on a hilltop looking out to sea. Following the coastline

along, you come to Penlee Point with its unusual grotto dedicated to Queen Adelaide. The path leads down to the village of Cawsand and then on to Kingsand and up through to the Mount Edgcumbe Estate.

Other attractions include the many deer that roam the estate, the old windmill at Empacombe, the medieval church at Rame, the obelisk at Cremyll, Lady Emma's Cottage and the ruins of the Pilchard Cellars at Kingsand.

Regular ferry journeys leaving from Stonehouse in Plymouth drop passengers off at Cremyll, enabling them to explore the wonderful Mount Edgcumbe Estate or travel on foot or by bus to the nearby villages of Cawsand and Kingsand.

There is so much to see and do within the Rame Peninsula and I feel very lucky living so nearby and being able to visit regularly.

I hope you will enjoy the old and new photographs within the pages of this book. I have tried to show not just the differences over the years but also the outstanding beauty of the area.

A hang glider soaring above Whitsand Bay.

Cremyll Quay

The lovely older photograph shows the ferry master waiting for passengers to arrive at the jetty. On the left, a horse and buggy wait to take passengers to their next destination. In the background is HMS *Impregnable* and sailors can be seen on the beach. The later photograph shows the Edgcumbe Arms and the stretch of road that once led to the tower that can be seen in the earlier photograph.

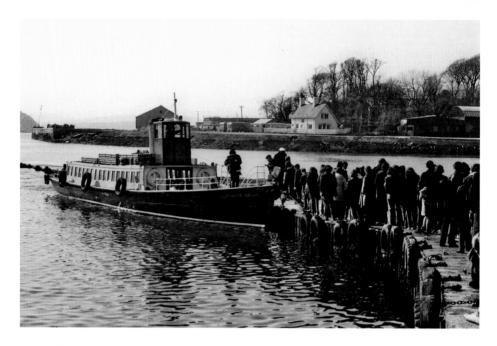

Admirals Hard

The earlier photograph shows passengers waiting to board the Cremyll Ferry at Admirals Hard, on the Plymouth side of the river. There has been a ferry in use here since Saxon times and it is first recorded in 1204. The later photograph shows the ferry arriving at its destination at Cremyll.

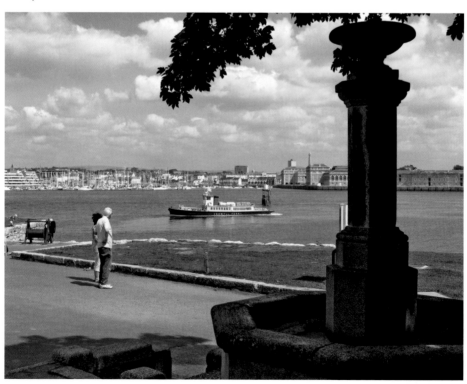

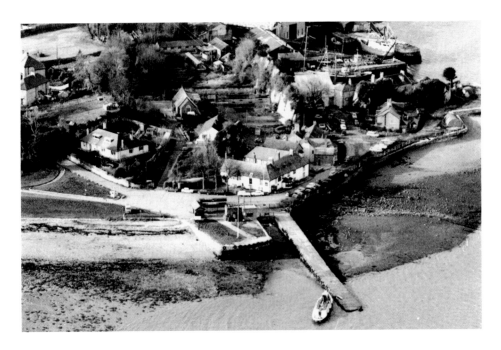

Aerial View of Cremyll

The first photograph shows an aerial view of Cremyll in the 1970s. The Edgcumbe Arms can be seen as well as the old school house and nearby houses. The second photograph shows a boat in for repair at Mashfords boat-yard, which can be seen on the far right of the earlier photograph.

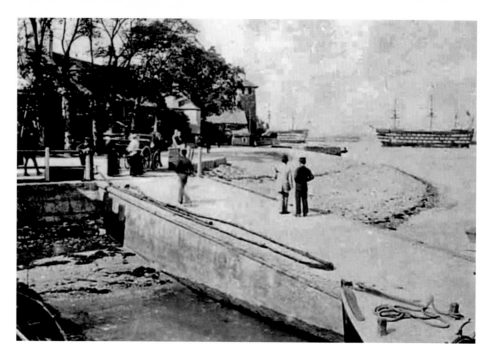

The Slipway at Cremyll

In the earlier photograph, the ferry has just arrived at Cremyll and the passengers are making their way up the slipway. There is much similarity to the more modern photograph but many of the buildings have disappeared due to being damaged during the heavy bombing of the Second World War.

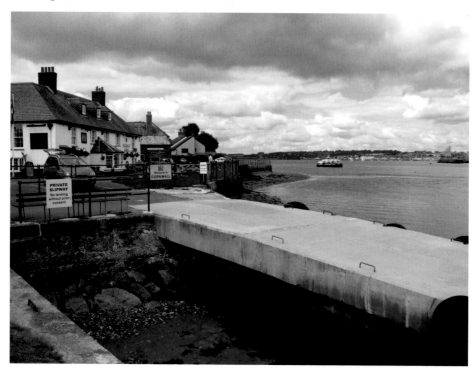

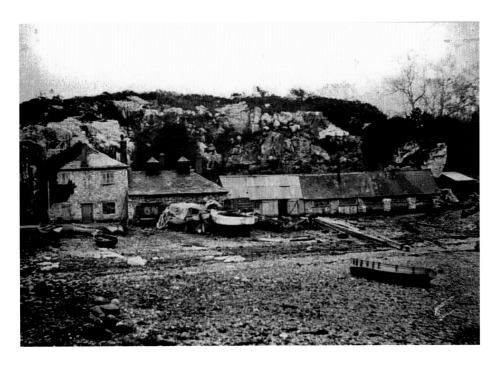

Mashfords Boat-Yard

Ships and other vessels have been serviced in the area for over 270 years. In 1774, the lease for Frank's Quarry was advertised after the death of shipwright, James Hennah. Between 1779 and 1812, the yard was operated by John Parkin who not only built vessels for revenue men but also built them for smugglers and privateers. The site was acquired by Mashford Brothers in 1930.

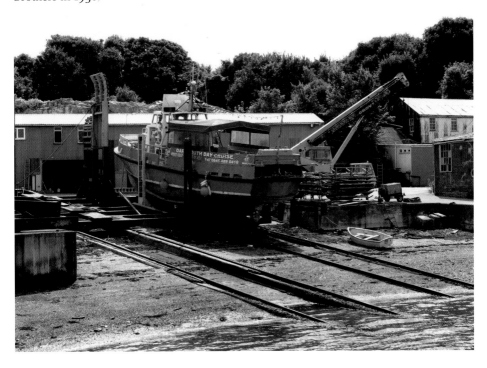

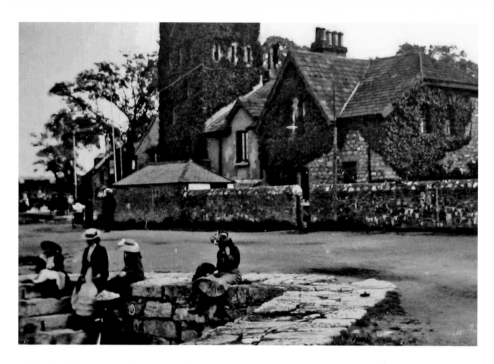

School Girls at Cremyll

Girls from the local school can be seen in the earlier photograph sitting by the harbour wall where there was also a small beach. The Italian Tower House in the background was destroyed by German bombing during April 1941. The Tower House was commissioned by Ernest Augustus Edgcumbe (1797-1861).

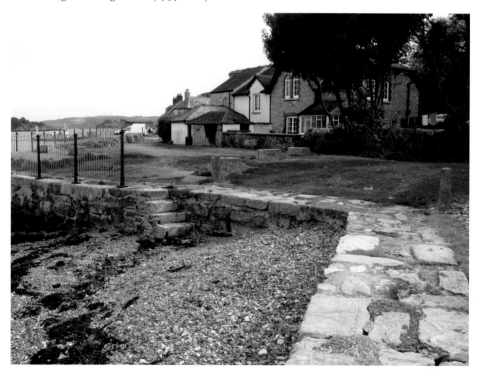

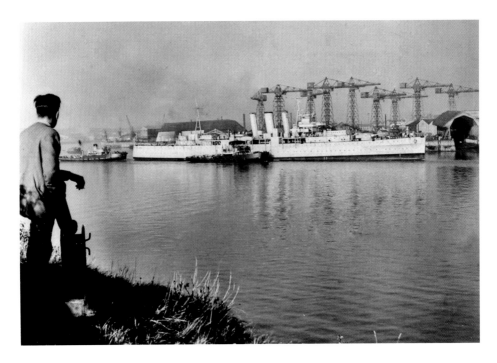

Mutton Cove from Cremyll

In the earlier photograph, a man looks over from Cremyll towards Plymouth dockyard. On the right can be seen the boat shed where wooden ships used in Nelson's Navy were built. The shed still stands today and beside it can be seen the statue of King Billy, which stands proudly at Mutton Cove.

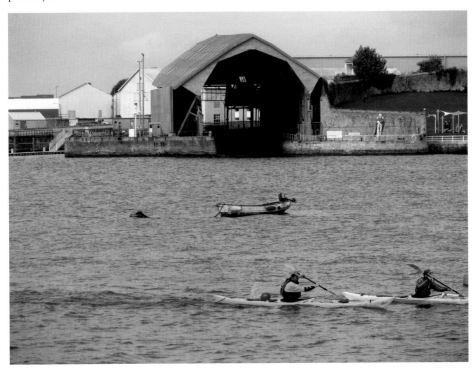

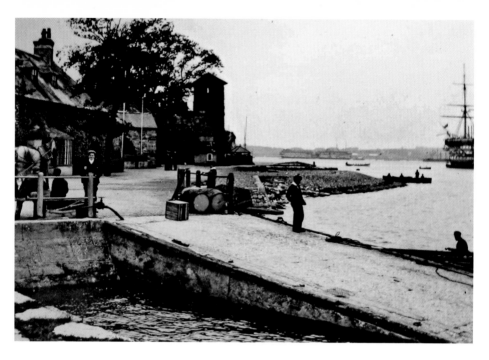

Vital Supplies, Cremyll

A wooden crate and casks of ale wait on the shore in the older photograph of the jetty at Cremyll. The later photograph shows holidaymakers boarding the ferry ready to return back to Plymouth. In the background can be seen the Royal William Yard at Stonehouse, which was built between 1826 and 1835.

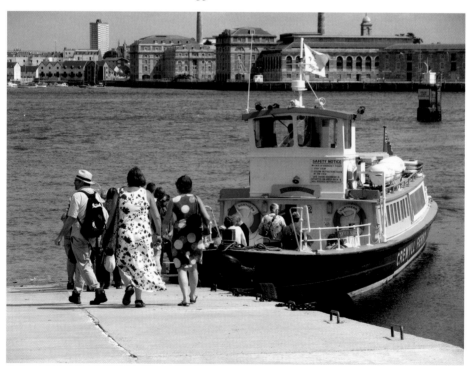

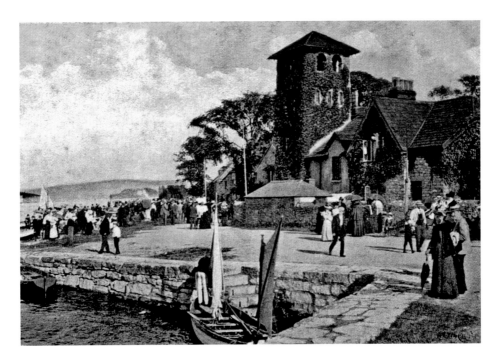

A Busy Scene at Cremyll

Cremyll and Mount Edgcumbe Estate were both very popular places to visit during Victorian and Edwardian times. This scene shows many people milling around the harbour. The ivy covered Italian-style bell tower can be seen in the background. When it was bombed in 1941, two ferrymen were killed by the blast.

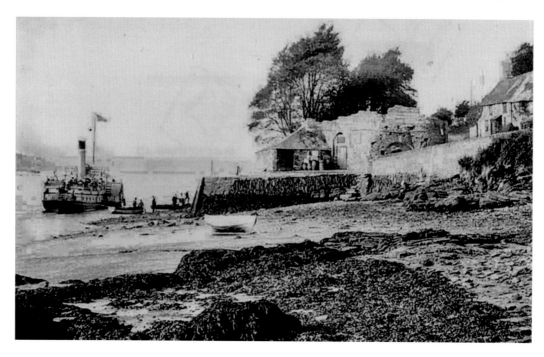

The Ferry Arriving at Cremyll

In the earlier photograph, two boats meet the ferry as it arrives at low tide. The ferry is a steam boat probably the SS *Shuttlecock* which was damaged in 1941, was rebuilt as a motor vessel, and renamed the *Southern Belle*. The *Northern Belle*, its counterpart, can be seen in the later photograph.

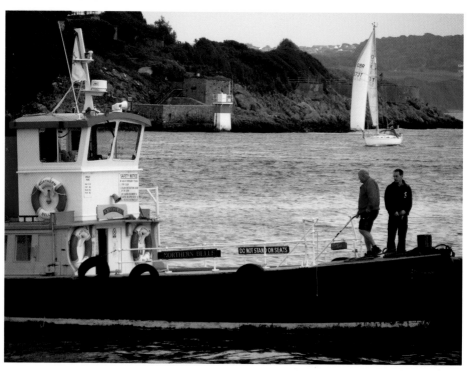

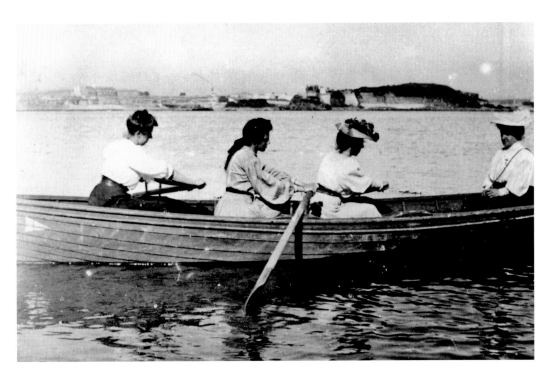

Rowers from Stonehouse

Boats could be hired from Sam Webber at Stonehouse Creek for 6*d* an hour and groups would row over to Cremyll and the Mount Edgcumbe Estate. The older photograph shows a group of ladies making their way to the shore. Drake's Island can be seen in the distance. The later photograph shows a more modern yacht passing nearby with the Royal William Yard in the background.

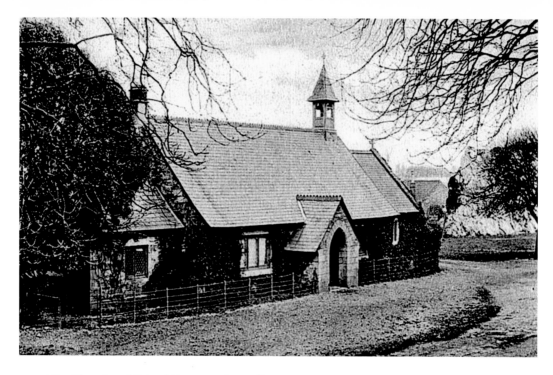

The Chapel and School House at Cremyll

The chapel was built in 1867 because Maker Church was felt to be too far away for parishoners to travel. Children of both local villagers and estate workers attended school there and it was open for many years. Today, the school's doors are closed to pupils and the building is now a private dwelling.

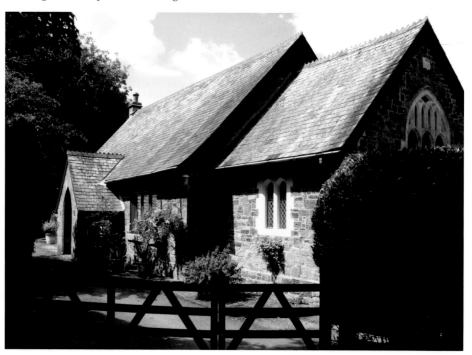

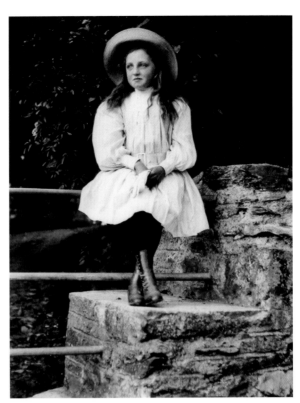

A Young Girl at Empacombe
The lovely older photograph shows a girl sitting on the bars at the end of Empacombe. The path behind leads down to Cremyll and the Mount Edgcumbe Estate. Further back on the hill at Empacombe stands an old windmill, which first appeared in records in 1729.

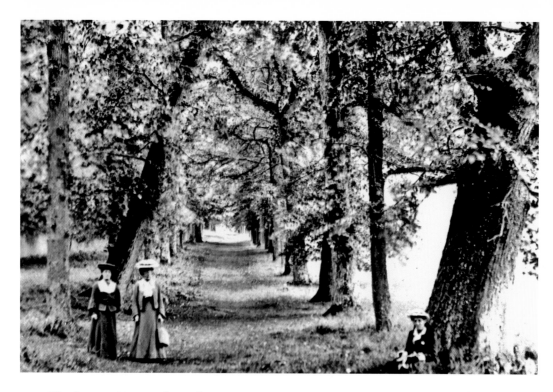

The Avenue, Mount Edgcumbe

The beautiful tree-lined avenue leads up towards Mount Edgcumbe House. The trees were devastated by the Great Blizzard of March 1891, which also damaged other areas of the estate including the beech plantation above Lady Emma's Cottage.

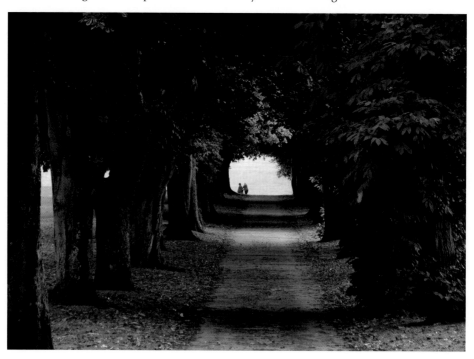

Heading towards Cremyll
The earlier photograph shows the avenue in winter time, looking towards Cremyll. The later photograph shows the view in the same direction and Plymouth can be seen across the water in the distance. The gates of Mount Edgcumbe can also be seen and there is a little shop on the left that sells plants, postcards and ice creams.

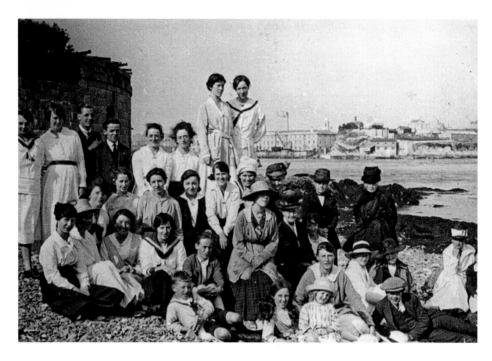

The Garden Battery

A group pose for the camera by the Garden Battery at Mount Edgcumbe. The Garden Battery was originally a saluting point with twenty-one guns in place to greet visitors. It was restored in 1747 but was rebuilt between 1862 and 1863 as part of Plymouth's sea defences. Today there are a lot less cannons but overall it looks much the same.

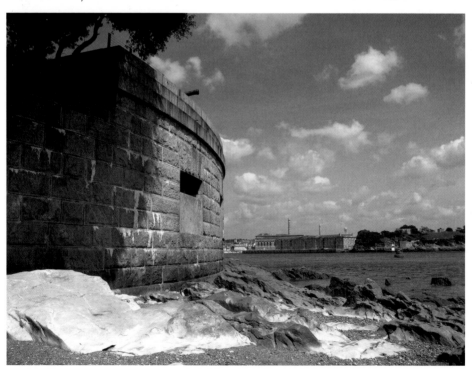

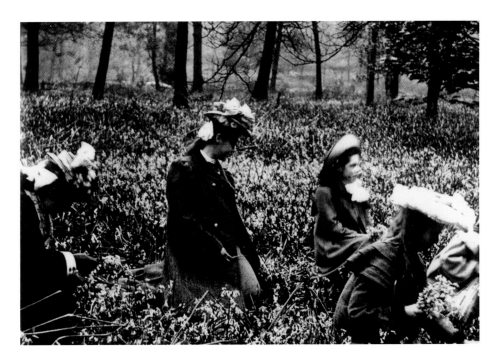

The Woods at Mount Edgcumbe

Mount Edgcumbe House can just be seen in the background of the first photograph. In spring, this part of the woods are covered with hundreds of beautiful daffodils. However, they appear to be covered in bluebells in the earlier photograph. It's an ever changing scene and the modern photograph shows October's autumn colours.

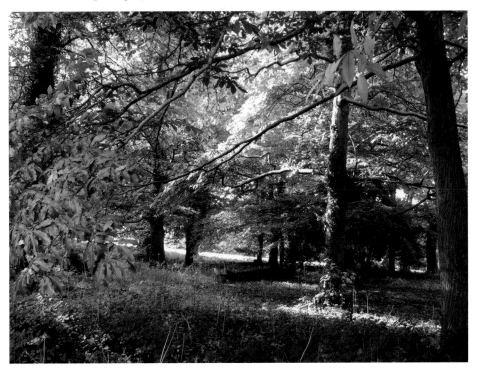

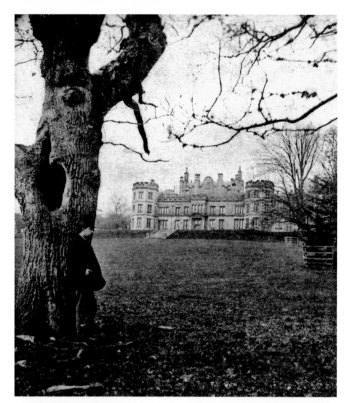

Mount Edgcumbe House
The earlier photograph shows Mount Edgcumbe House as it once was, before enemy bombing in the Second World War. It once had a white smooth stucco finish but when it was rebuilt in 1958, the rendering was removed from its walls leaving its present red sandstone appearance. The entrance at the North front still has its original sixteenth-century doorway and is surrounded by late seventeenth-century Doric pilasters and a pediment. The house is decorated in neo-Georgian style.

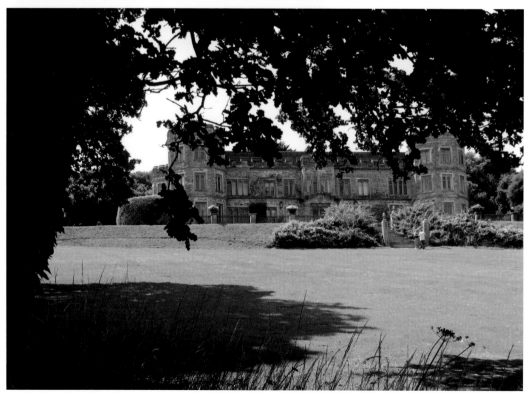

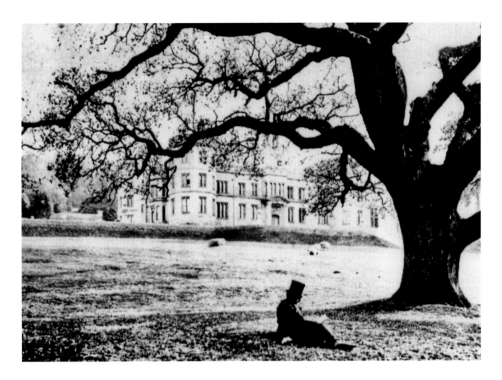

Relaxing at Mount Edgcumbe

The earlier photograph shows a Victorian gent taking it easy beneath a sprawling tree. Today, the lawns leading up to the house see much use with visitors having picnics, playing football or just enjoying the view. To the left of the more recent photograph can be seen the Earl's Garden which adjoins the main house.

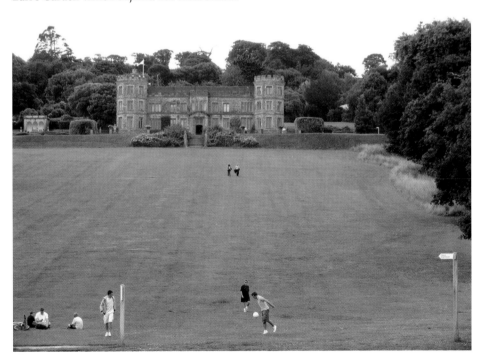

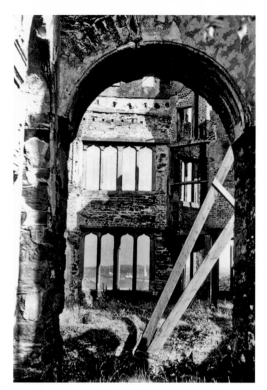

Bomb Damage, Mount Edgcumbe House
When the house took a direct hit on the
22 April 1941, little was left except the shell
of the building. Many of the Edgcumbe
family's possessions were destroyed
including rare furniture and paintings. Three
generations of the Edgcumbe family were
painted by Joshua Reynolds and all but one
were destroyed.

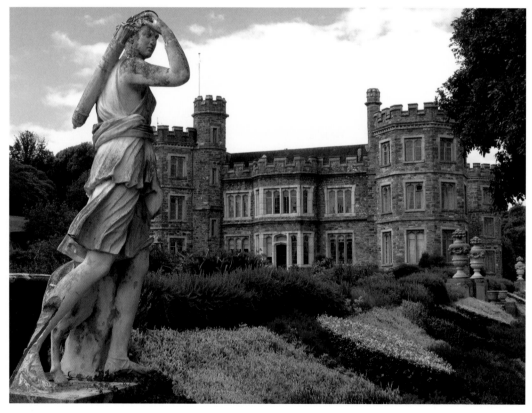

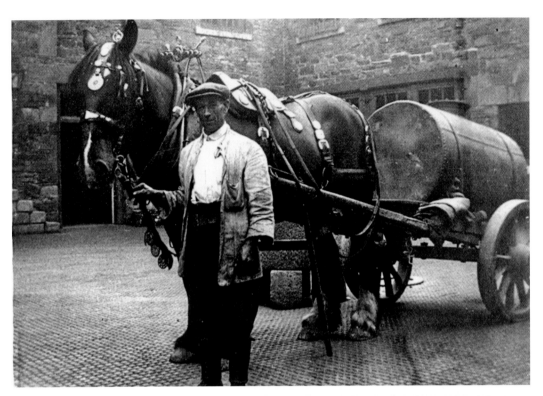

The Stables at Mount Edgcumbe
The older photograph shows Mr Chamberlain who was a carter on the Edgcumbe Estate. Today the stables have become a café, a shop and an exhibition centre. Many displays take place there and there are many photographs of how the estate once looked. A remote camera also lets you watch the bats that roost within the roof space of the buildings.

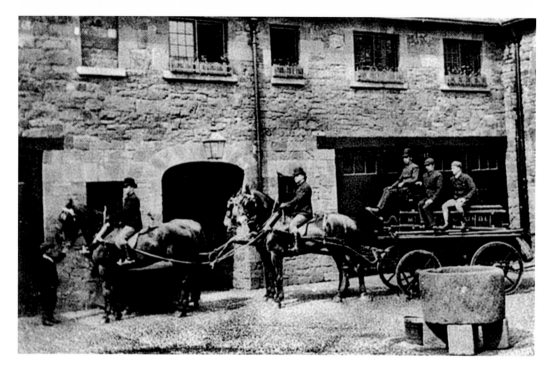

The Mount Edgcumbe Fire Brigade

The fire brigade can be seen at the stables at Mount Edgcumbe. Today the area behind the cart houses a shop selling books and souvenirs. The archway on the left leads to the bat cam and the old workshops. The trough in the photograph still remains and is a feature near to the café. The old fire engine is also displayed nearby.

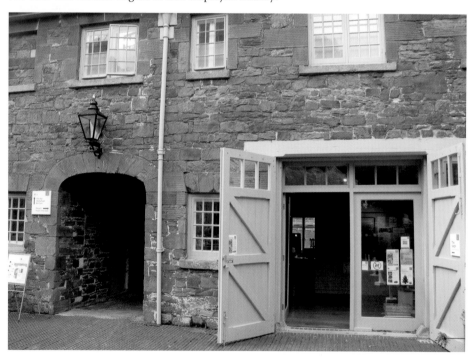

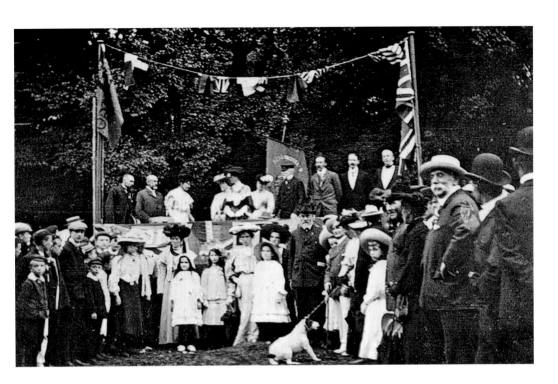

Prize Giving Event

The older photograph shows a gathering at Mount Edgcumbe in the early 1900s. It appears to show a prize giving event and many people have gathered to watch. The later photograph shows the ice house which is situated beneath the walkway leading to the main house.

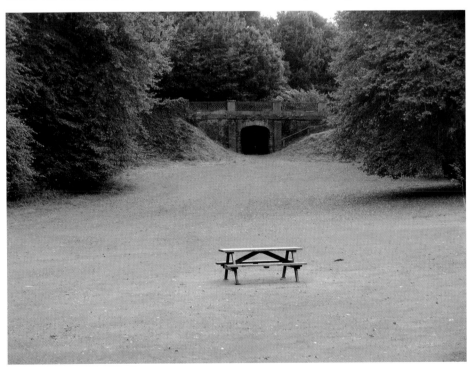

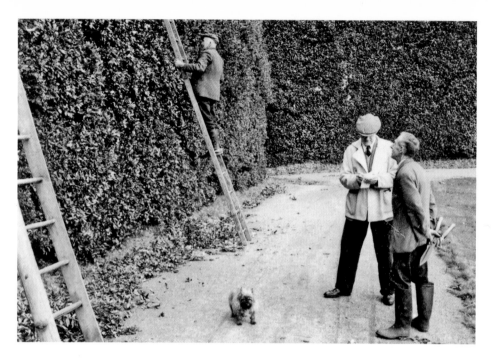

The Great Hedge, Mount Edgcumbe

The great hedge is made up of Ilex and measures 10 metres high. It forms a giant windbreak that protects the gardens from the cold easterly winds. In the earlier photograph, the Earl of Mount Edgcumbe can be seen with the gardeners, Mr Walters and Mr Phillips, who are trimming the hedge. Today, the hedge looks much the same.

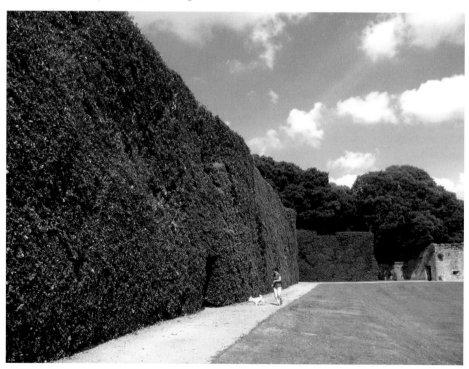

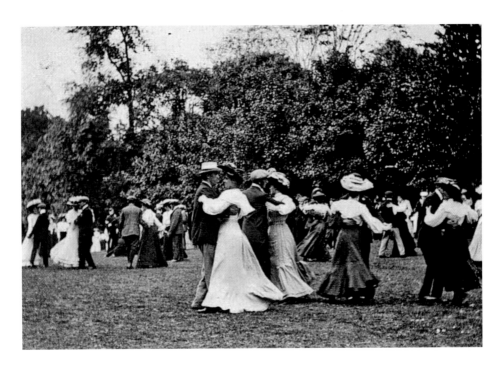

A Dance at Mount Edgcumbe

The first photograph shows a dance at Mount Edgcumbe in the early 1900s. Everyone is dressed in their best clothes and the ladies are wearing fancy dresses and hats. There are many open grassed areas at Mount Edgcumbe and the dance may well have taken place in the Barn Pool area of the estate.

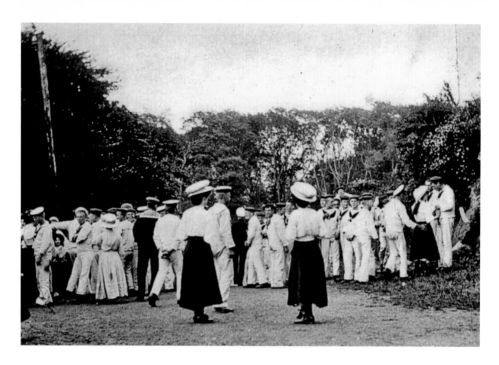

Sailors from HMS *Impregnable*

In the older photograph, sailors gather to meet suitable dancing partners. The sailors were probably from HMS *Impregnable,* which was moored off the quay at Cremyll. The newer photograph shows Barn Pool, which is still very busy today, especially in the summer months, although sailors are few and far between.

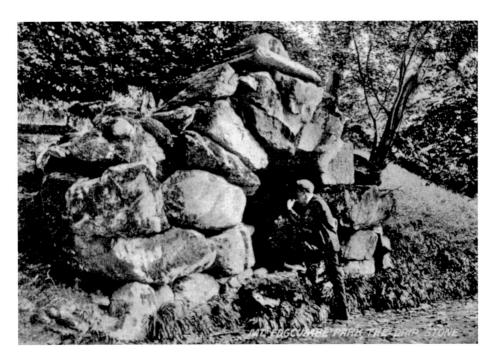

The Drip Stone

The Drip Stone is one of the many follies that are built on the Mount Edgcumbe Estate. It can be found beside the path on the way to the duck pond and Milton's Temple. Little has changed over the years and people still stop to gaze inside, just like the Victorian gent in the earlier photograph.

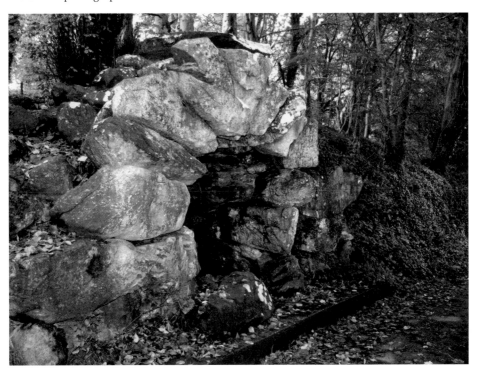

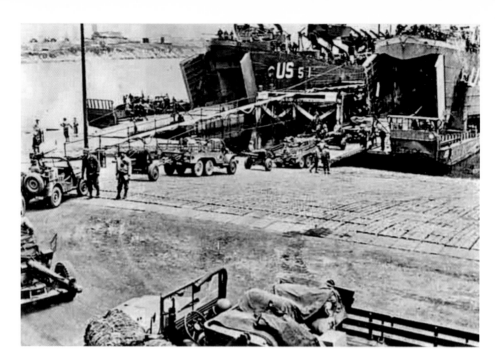

US Troops at Barn Pool

During 1944, the US Army (110th Field Artillery of the 29th Infantry Division) occupied the area around Barn Pool before leaving for Normandy to take part in the D-Day landings. Evidence of their time there can still be seen today and remnants of the 'hards', that their vehicles drove over, can be found scattered on the beach. Today, a regular military vehicle gathering is held in the area each year.

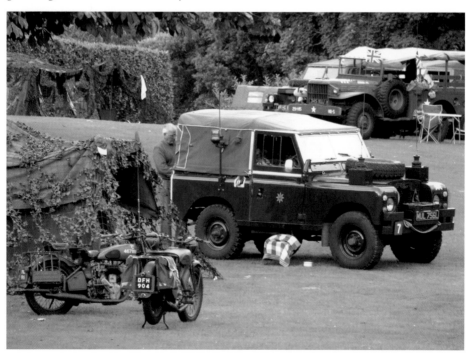

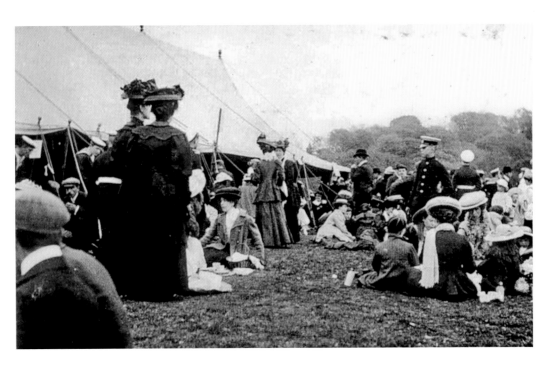

A Picnic at Mount Edgcumbe

In the first photograph, military men mingle with the ladies and children having a garden party on the Mount Edgcumbe Estate. A huge tent has been set up on the left and everyone has turned out in their best clothes. The area is still very popular and regular events such as the classic car show are held nearby.

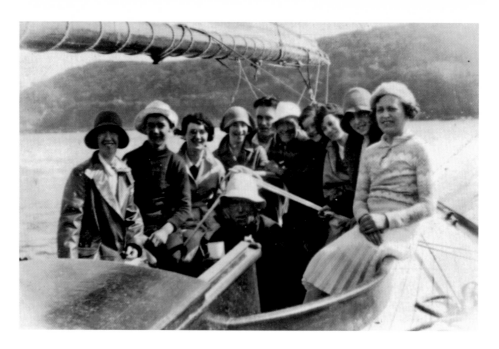

A Boat Trip, 1935

The earlier photograph shows some of the staff of Mount Edgcumbe house taking a trip in a yacht in 1935. The estate can be seen in the background. Barn Pool is a sheltered deep water area of Mount Edgcumbe where a large polished stone axe was found by divers near a reef there. The area is likely to have been above sea-level during Neolithic times. The area was also used by the Vikings in 997.

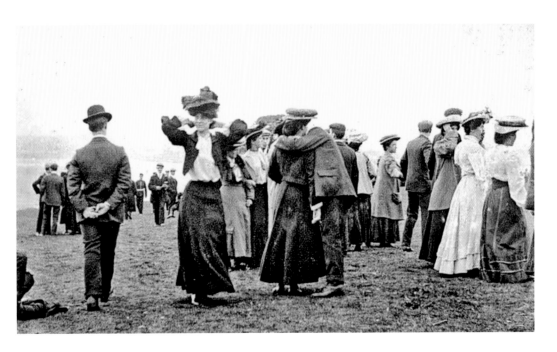

Kiss in the Ring

The older photograph was marked 'Kiss in the Ring' on the reverse, but little more is known about it apart from that it shows a social gathering in the grounds of the Mount Edgcumbe Estate in the early 1900s. Young ladies seem to be on the look-out for suitable suitors. The newer photograph shows the same area today and features the concrete roads laid by American troops during 1944.

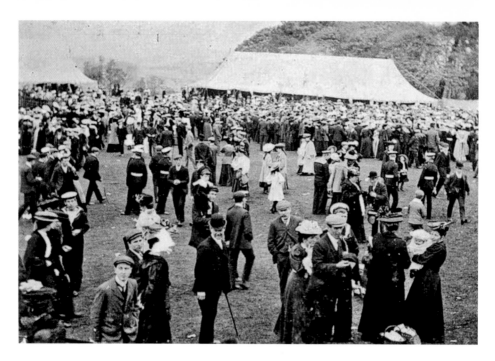

A Social Gathering

These two photographs show scenes of a very busy Barn Pool. In the first photograph, sailors and other military men mingle in the crowd which includes men, women and babies. The later photograph shows the area today with many people enjoying themselves. In the background can be seen the garden battery and the Royal William Yard at Stonehouse.

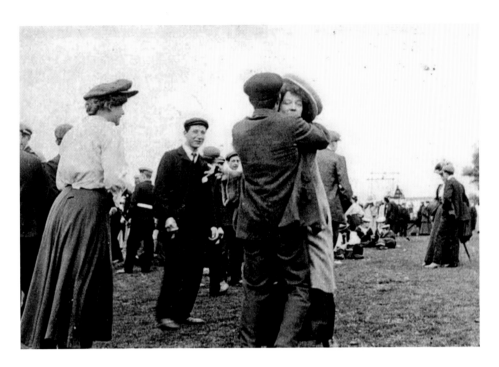

Recreation at Barn Pool

More revellers are shown in the older photograph which was probably taken at Barn Pool. The *Beagle* sailed from Barn Pool on the 27 November 1831 and, after circumnavigating the globe, returned back to England after an absence of four years and nine months.

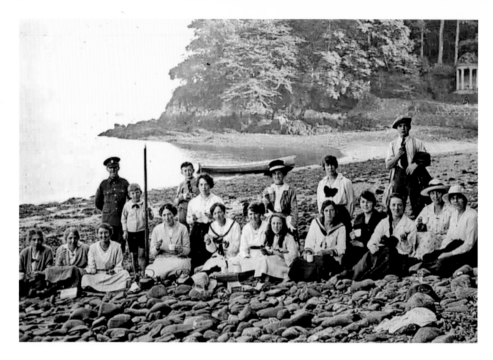

Milton's Temple

A group gather beside Milton's Temple after rowing over to Mount Edgcumbe from Plymouth. They are accompanied by a soldier in First World War uniform. Milton's Temple was built in 1755 and is of a circular Ionic style. John Milton died in 1674, long before the temple was built, but the words from Paradise Lost appear on a plaque on the temple's walls.

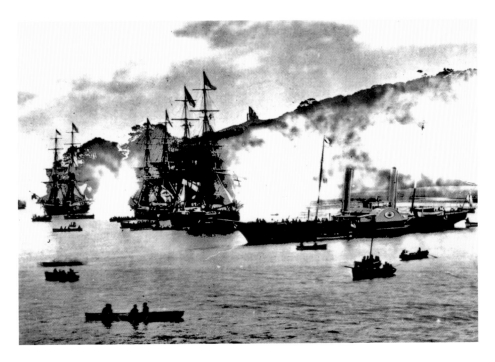

Mock Battle at Barn Pool

The older photograph shows a mock battle put on to entertain the Royal visitors to Barn Pool in 1880. Ships that took part in the battle included the training brigs, *Liberty Pilot* and *Nautilus*. The waters here have welcomed many ships and their visitors for several hundred years, including royalty and the celebrities of the day.

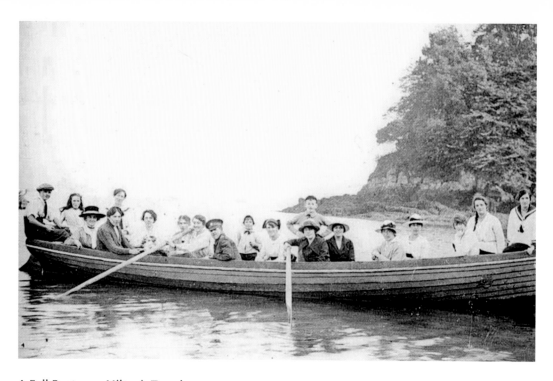

A Full Boat near Milton's Temple

The group seen earlier beside Milton's Temple appear to be ready to row back to Plymouth. Today it would probably be unheard of for anyone to row in such a boat over to Mount Edgcumbe, but the waters are regularly visited by yachts, motor launches and canoeists.

Leading up to the Folly at Mount Edgcumbe

Both photographs show the wooded path that leads up to the Folly. Little has changed over the years and hundreds of holidaymakers still visit today. The ladies in the earlier photograph were probably making their way to the tea gardens at the nearby Lady Emma's Cottage.

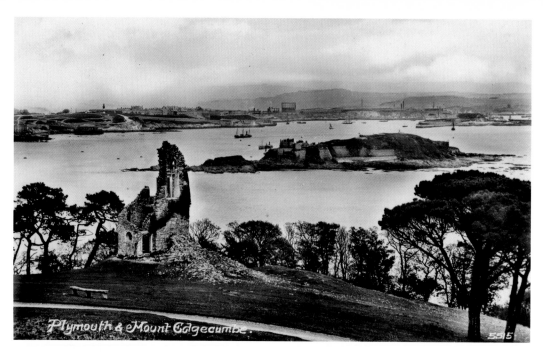

Plymouth & Mount Edgecumbe.

The Folly

The Folly was built in 1747 and replaced an obelisk which had stood on the site previously. It was built by using medieval stone from the churches of St George and St Lawrence which once stood in Stonehouse. The Folly has always looked like this and was built to look like an old ruin.

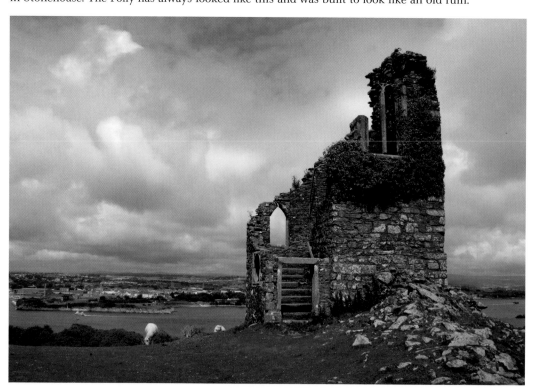

A Daytrip to the Folly in 1928
The boy on the left in the older
photograph is exploring the Folly
while this photograph is being
taken. The man in the middle
is holding an old Kodak Box
Brownie camera so there would
have been more photographs
of the trip. I wonder if the
pictures still survive? In the later
photograph, Plymouth Hoe can
be seen in the background.

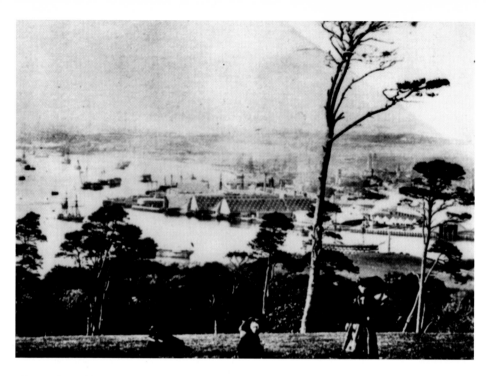

The Dockyard from Mount Edgcumbe

In the older photograph, the view of Plymouth dockyard can be seen from the Deer Park at Mount Edgcumbe. The newer photograph shows the view of Devonport that can be seen from the same spot today, which includes blocks of flats as well as a more modern dockyard.

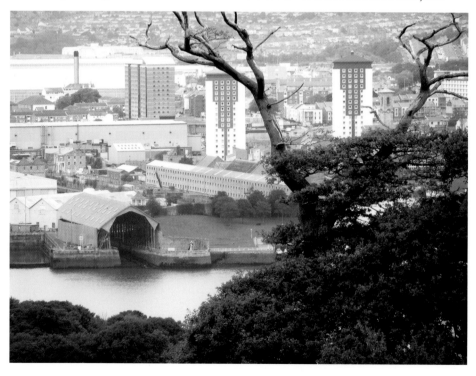

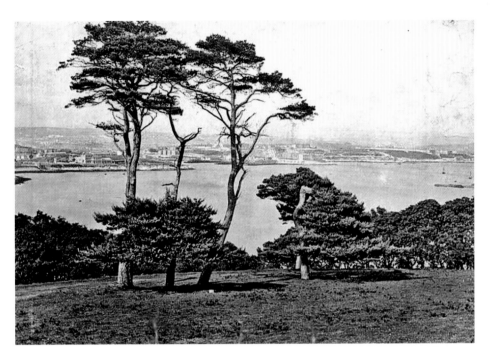

The Deer Park

The top photograph shows a view of Plymouth from the Deer Park. The park has changed little over the years and deer descended from the original herd, first brought to the park in the 1500s, still roam free. In the later photograph, Plymouth has grown greatly and much has been rebuilt after the heavy bombing of the Second World War.

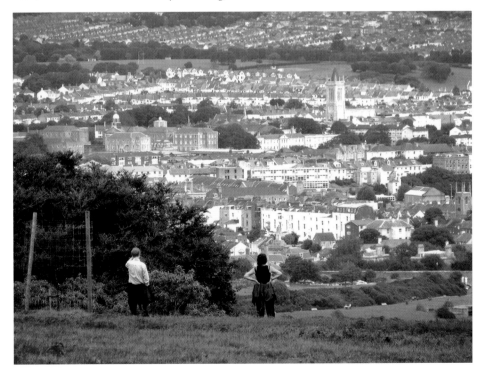

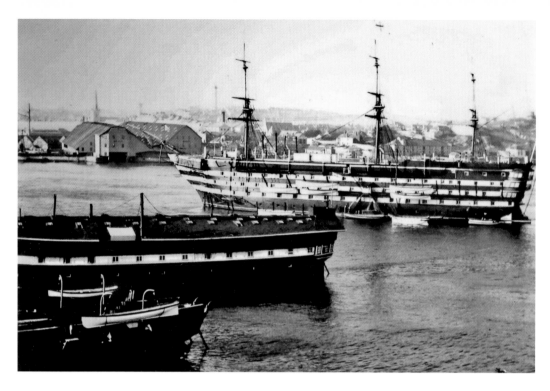

The Dockyard

The dockyard and ships moored off Cremyll can be seen in the older photograph. Vessels such as these have long since disappeared. The later photograph shows the busy scene in front of the Mount Edgcumbe Arms with views looking across the Tamar.

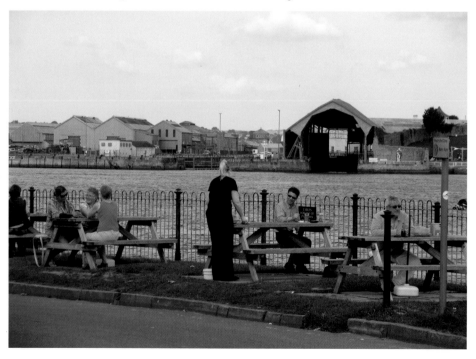

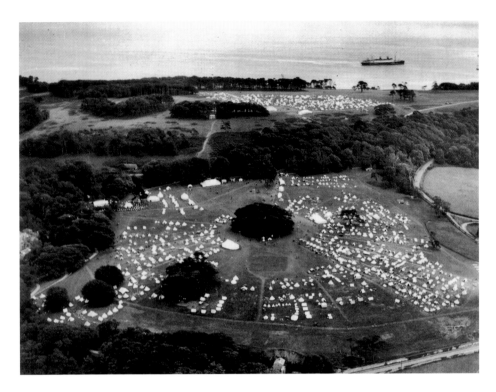

A Scout Jamboree

The first photograph shows an early scout jamboree in the fields above West Lodge and continuing up into the Deer Park. The now much damaged Harbour View Seat, also known as the White Seat, can be seen in the background. Mount Edgcumbe House can be seen on the far left of the photograph. The later photograph shows the fields near Barrow Park.

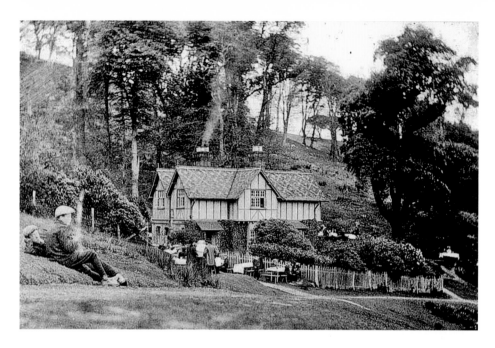

Lady Emma's Cottage

The original cottage was built in Beechwood in 1760 and it burned down in 1880. It was rebuilt as Lady Emma's Cottage in 1882. The cottage was named after Lady Emma Edgcumbe who was the daughter of the Second Earl of Mount Edgcumbe. The rebuilt building was still known as Beechwood Cottage for many years. During Victorian times, it became a very popular tearoom for the many people who visited the Mount Edgcumbe Estate.

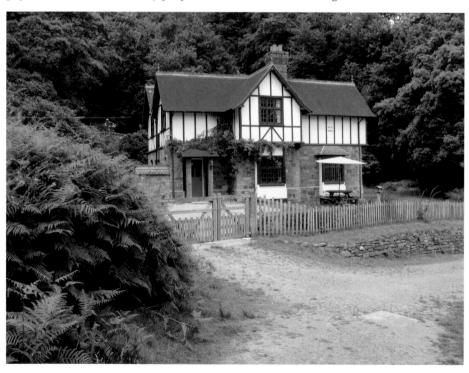

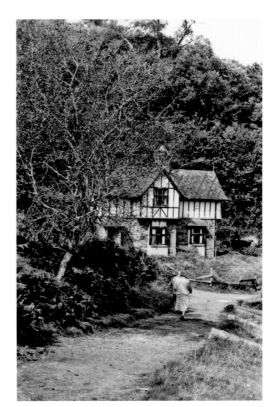

The View from Lady Emma's Cottage
Today, the cottage has been refurbished and
is let out to holiday makers. The later view
looks from the cottage towards Plymouth
Sound and Drake's Island. The earlier
photograph shows the cottage as it was in
the 1960s.

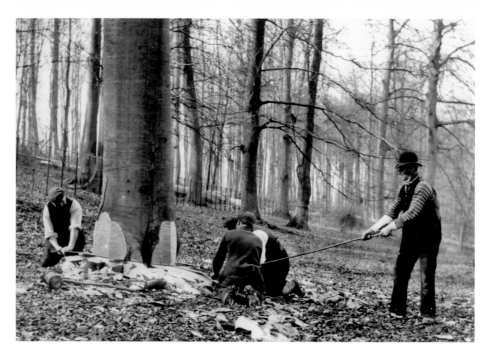

Tree Cutters on the Mount Edgcumbe Estate

In 1906, the Earl employed thirty-two gardeners and eight woodrangers. In the older photograph, workers can be seen cutting down a tree which to be looks a long and labourious process. Here they can be seen using a two man crosscut saw, and a wooden mallet and wedge to carefully guide the direction in which the tree falls. Old wood saws have now been replaced by more modern tools including more efficient chain saws.

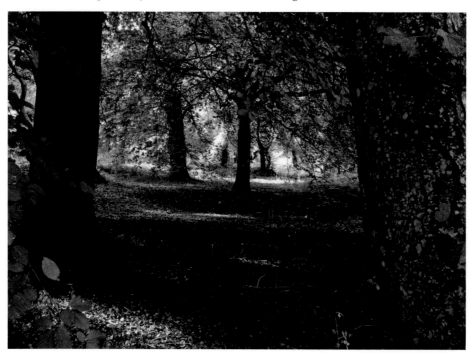

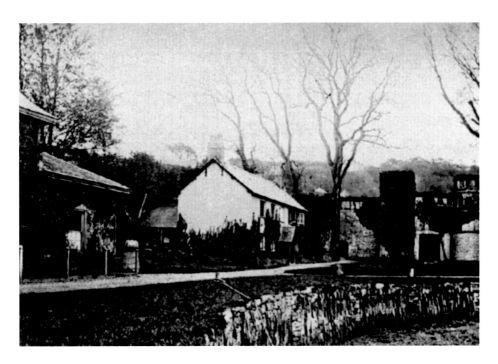

Empacombe

John Rudyerd lived at Empacombe in 1706 together with his Eddystone Lighthouse workshop. Rudyerd's lighthouse was built of wood and was completed in 1709. Today, the present Earl of Mount Edgcumbe lives nearby. Little has changed over the years although there is a newer wall which guides walkers away from the houses.

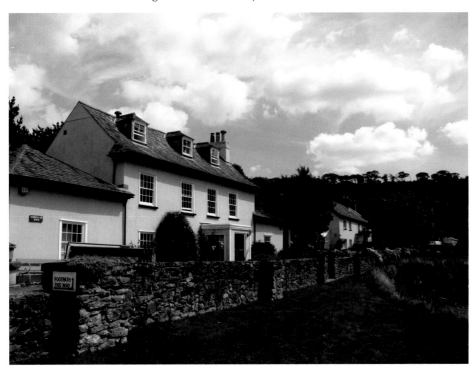

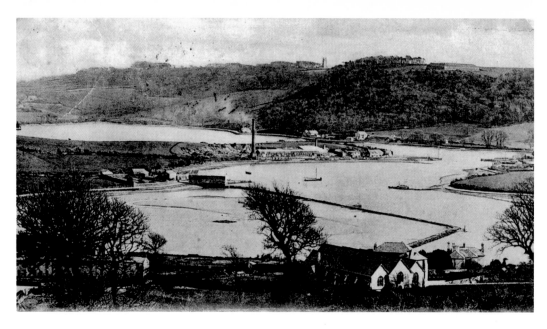

Millbrook Lake

The older photograph shows Millbrook Lake with Foss Brickworks in the centre. The brickworks have now long gone and more modern housing appears in their place. Many yachts now moor in the lake, which is also home to swans, geese and ducks.

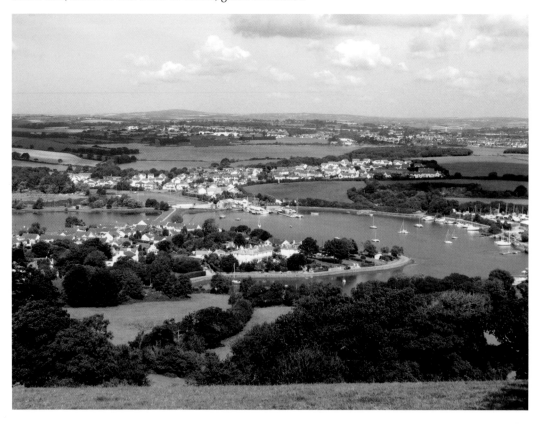

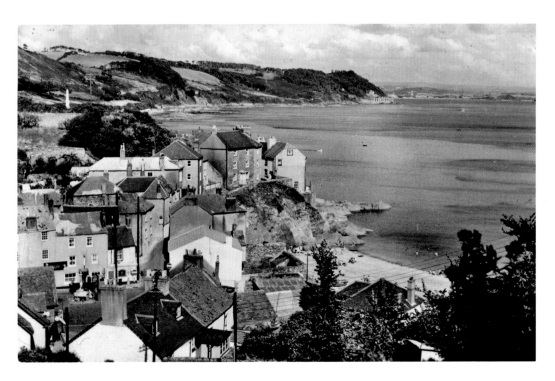

Cawsand

Cawsand was once a busy fishing village and home to a very rewarding smuggling trade. It still retains many of its original buildings, although most fishermen and their families left many years ago. Most of the houses today are holiday homes and at certain times of the year the village is empty, but visitors from London seem to dominate it during the holiday periods.

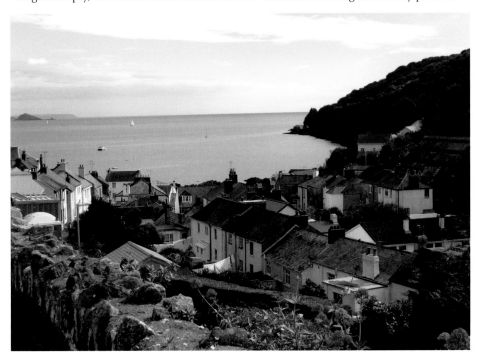

The Car Park, Cawsand
The busy car park at Cawsand was once a beautiful meadow that ran down beside the Spanish-style house that stands nearby. Originally, the area was donated as a children's play area and there was much outcry from villagers when the area was tarmacked over.

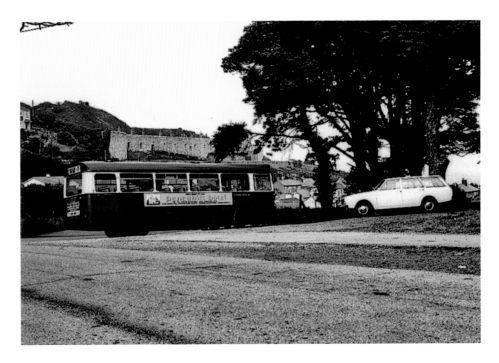

Old Transport, Cawsand

The earlier photograph shows an older style bus and car near to the car park. In the background can be seen Cawsand Battery. The Battery was originally built in 1779 and rebuilt between 1860 and 1867. Today, it has been converted into private dwellings. The newer photograph shows the nearby Spanish-style house mentioned previously.

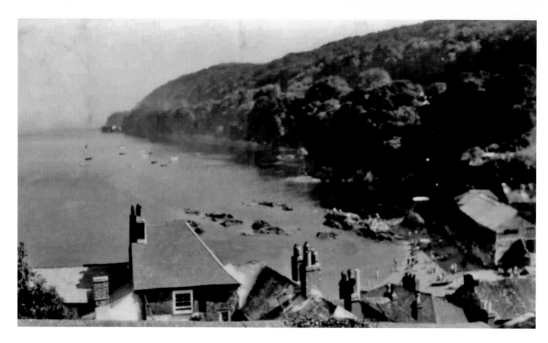

New Road, Cawsand

These two photographs look over the village of Cawsand towards Penlee Woods. The house on the left is easy to match up in both photographs. In the newer photograph, the Cawsand Inn can be seen beside the beach and many people are sunbathing nearby.

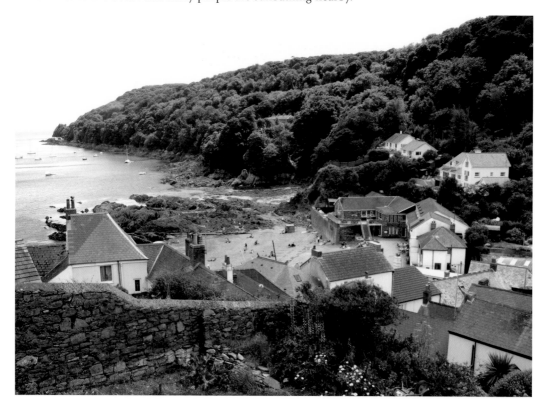

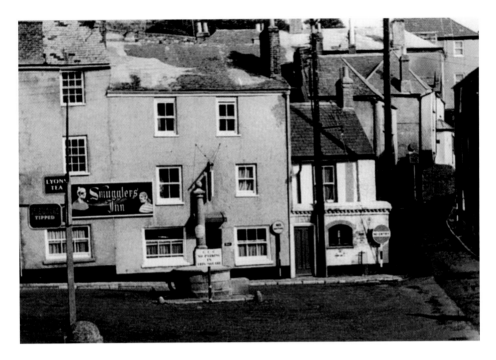

The Smugglers Inn

For hundreds of years, Cawsand was a busy and lucrative smuggling village. The inn took its name from its past activities. The older photograph has some interesting tin signs including one for Lyons Tea. Today, the inn has been renamed The Cross Keys. The many vans in the square are commonplace as houses are renovated into holiday homes.

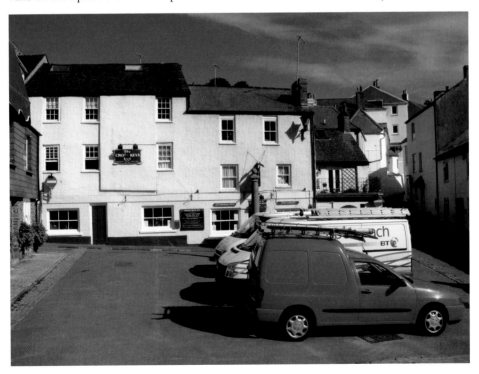

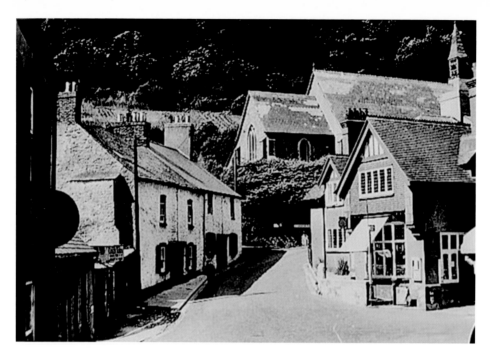

The View Looking Back from Cawsand Square

These two images show the houses and shops as viewed looking up the hill from Cawsand Square. The village shop was closed for many years but has seen a new lease of life in recent times. Some of the buildings have altered and changed but the area is still instantly recognisable from the older photograph.

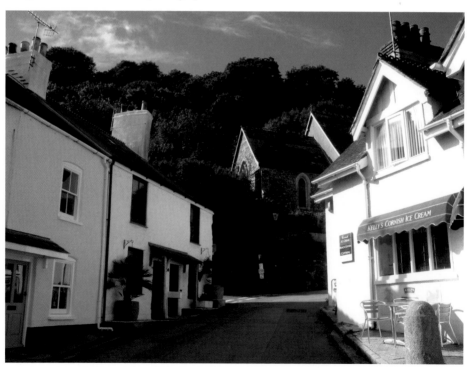

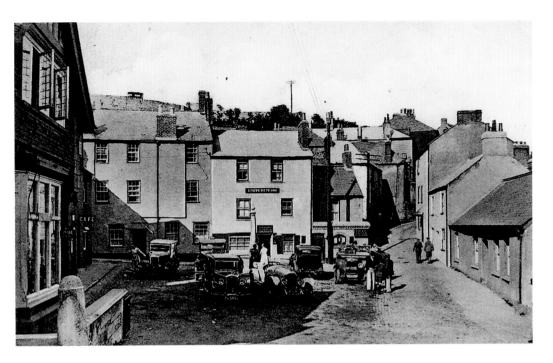

The Square at Cawsand

This older photograph of the square shows a lovely collection of vintage cars and it's interesting to see that the inn was called The Cross Keys, long before it became The Smugglers. On the left is a small café and the premises nearby advertise that they have a telephone if anyone should want to make a call.

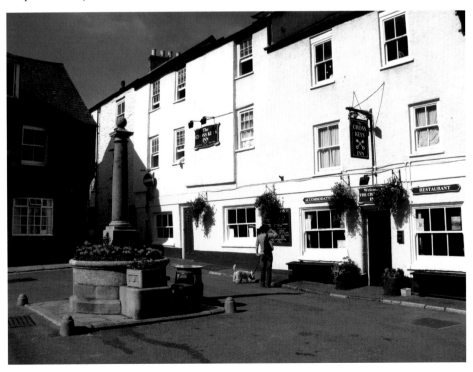

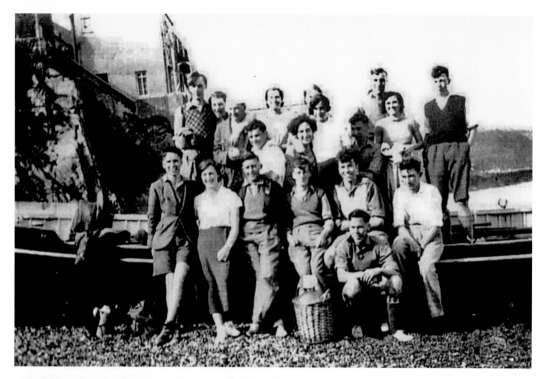

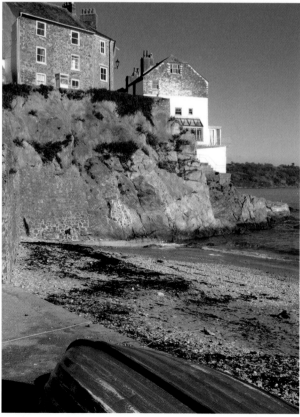

The Pennycross Methodist Club
The earlier photograph shows
the Pennycross Methodist Club
on Cawsand Beach in 1924.
Each church had its own rowing
club and members would row
long distances to places such as
Rame, the Mewstone and the
Breakwater.

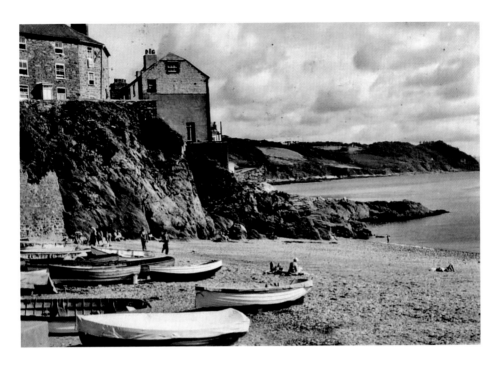

Cawsand Beach

Much remains the same in these two photographs. The beach is still popular with holidaymakers and many small boats still line its sands. In the far distance can be seen Kingsand and Fort Picklecombe. The houses above the beach have changed slightly with recently built modern conservatories.

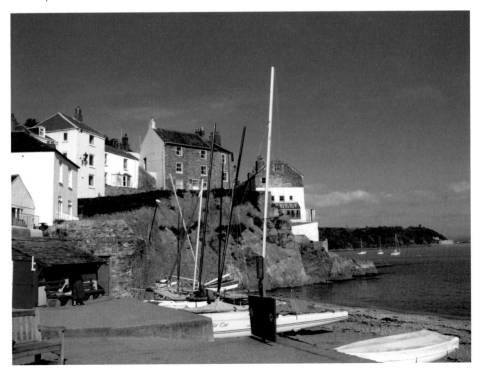

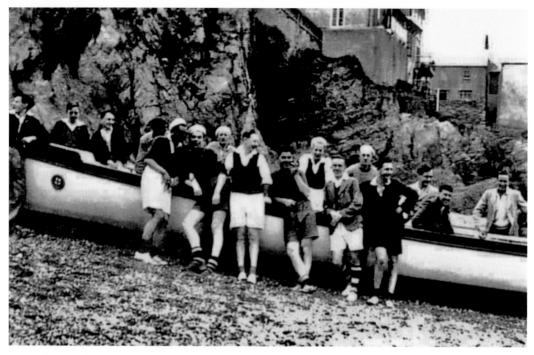

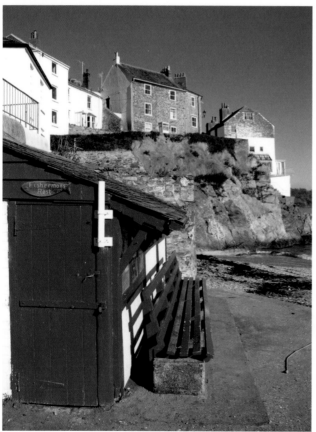

St George's Road Methodist Club

The older photograph shows another Methodist Rowing Club enjoying the beach at Cawsand. It would have been quite a journey at the time and rowing all the way over from Plymouth would have been quite a tiring job. Many members came complete with picnics and some even brought old fashioned wind-up gramophone players.

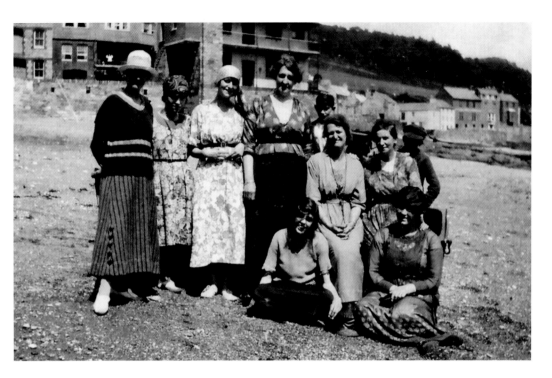

The Clock Tower at Kingsand

The earlier photograph shows a group of ladies and a couple of small boys gathered on the beach in front of the Clock Tower in 1921. Behind them, a girl is watching the proceedings from a balcony. The later photograph shows just how little has changed over the years.

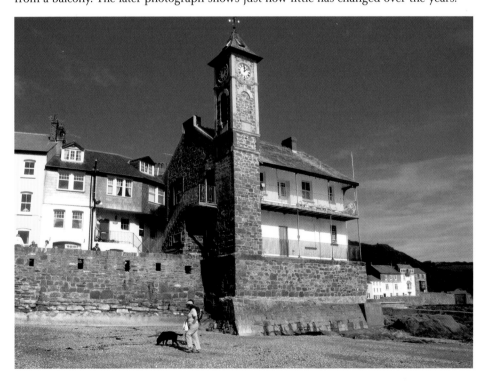

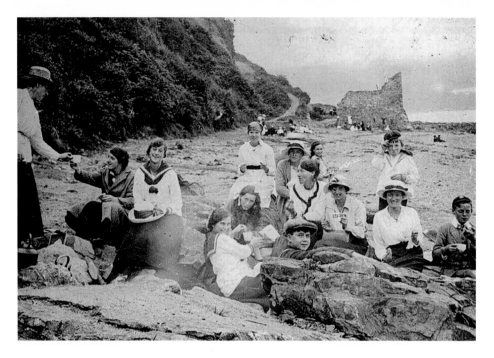

A Group on Kingsand Beach

The first photograph shows a group having a picnic on Kingsand beach. In the background are the remains of the old pilchard cellars. Richard Treville, an Elizabethan merchant, owned fish cellars here and he exported *fumados*, which were smoked pilchards. These were known as 'fairmaids' to the French and Spanish. Treville Street in Plymouth is named after him.

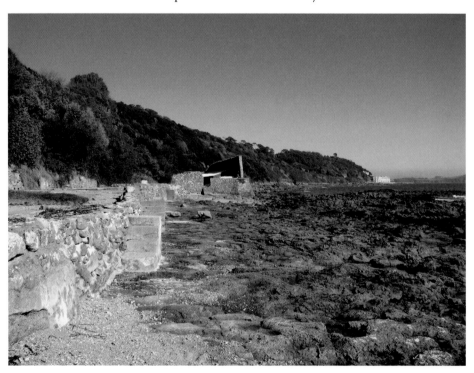

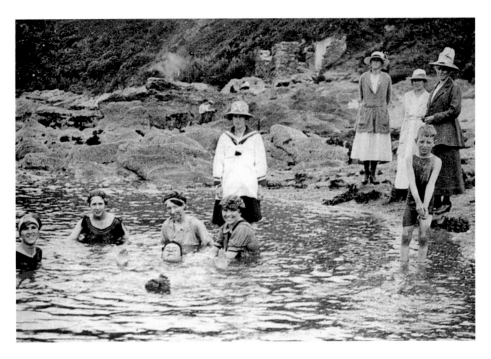

Taking a Dip at Kingsand

The same group can be seen having a swim in one of the natural pools at Kingsand. It's interesting to see how the fashions and swimming costumes have changed over the years. Further along, the area in the background has now been concreted over and people camp there every summer.

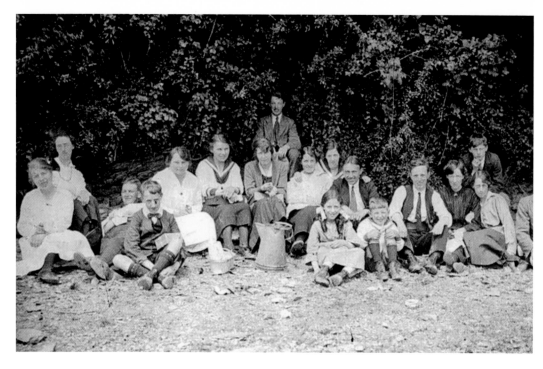

Smiling Faces at Kingsand

The older photograph shows a smiling, happy group complete with a water pitcher. It would probably have been quite a journey over to Kingsand from Plymouth in those days and I'm sure that everyone would have talked about it for weeks afterwards.

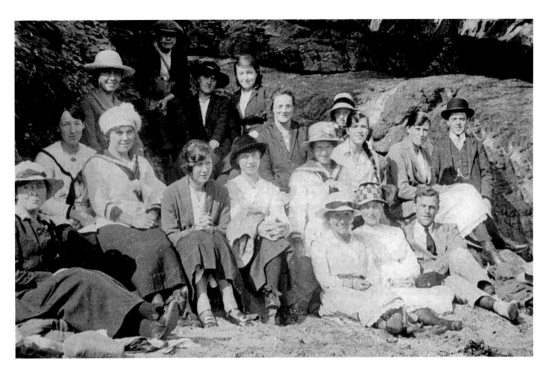

Beach Huts at Kingsand

It's easier to see, in the later photograph, the area that has been concreted over and is now used by the canvas-type beach huts. The tents are occupied every year and have only the most basic amenities. Even so, they have proved very popular for many decades and getting a pitch can prove quite difficult.

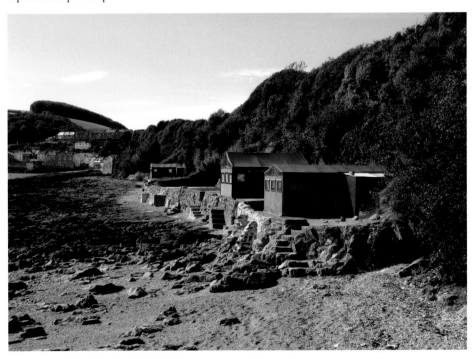

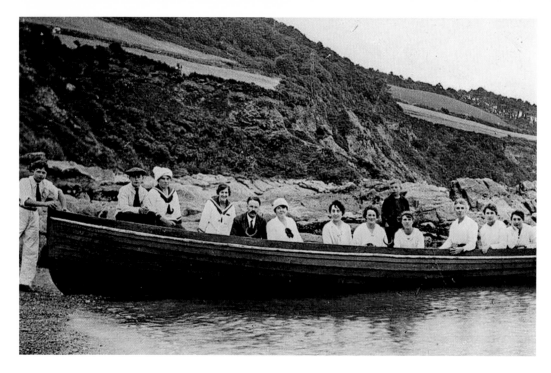

Rowing Home

A group on Kingsand beach prepare to row back home, probably to Plymouth. The grass sloping bank, which is used by many walkers travelling from the Mount Edgcumbe Estate to Kingsand, can be seen in the background. The area is practically identical today.

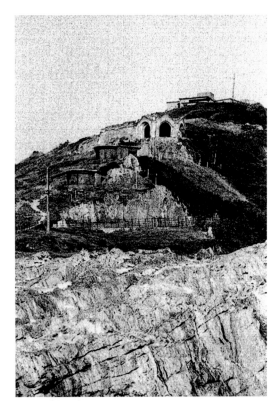

Queen Adelaide's Grotto, Penlee Point
Queen Adelaide's Grotto was originally just
a cave and was used as a watch house in
the eighteenth century. It was enhanced
with an arched stone frontage and became
a grotto after Adelaide's visit in 1827. If
you didn't know it was there, it would be
easy to miss as it is set down from the
main walking path above.

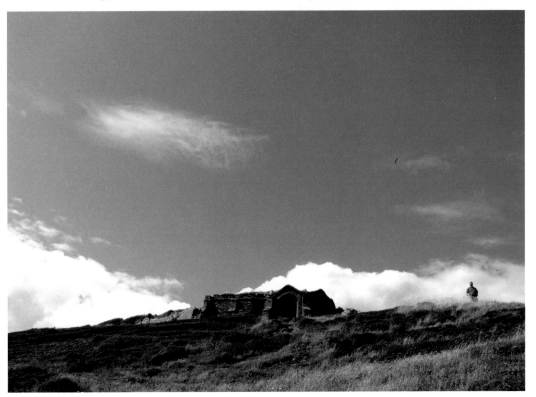

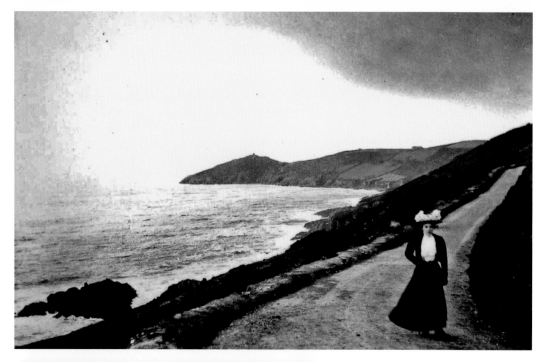

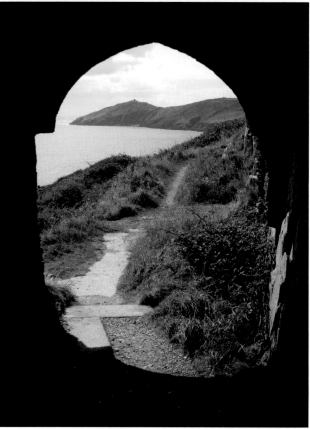

The View Towards Rame Head
A Victorian lady is shown walking towards Penlee Point. Rame Head can be seen in the background. She seems very well dressed for such a long walk and maybe the outfit was for some other function. The newer photograph shows the view of Rame Head from the entrance of Queen Adelaide's Grotto.

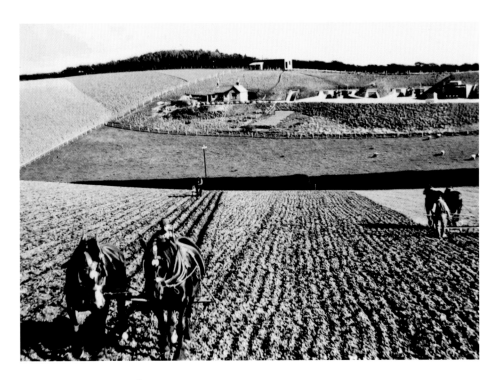

Farming at Rame Head

The older photograph shows the once traditional way of ploughing fields using two strong horses. Today, the technology is far more advanced and a job that might have taken several days can now be done in a fraction of the time.

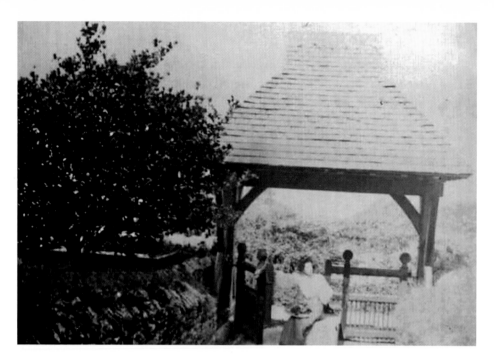

The Lych Gate at St Germanus Church at Rame

St Germanus Church at Rame was enlarged and rebuilt in the thirteenth century, although an older church once stood there. The stone plinth was where bodies would be laid before burial. It's still there today so next time you sit down for a rest, as the person in the earlier photograph has done, think of what might have been there before you.

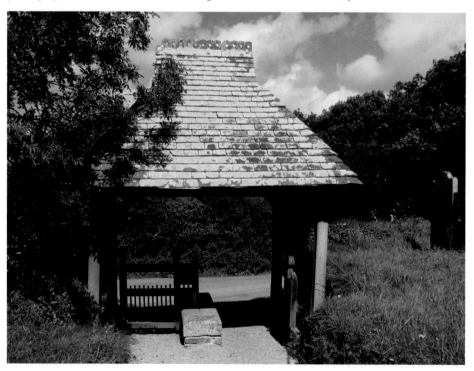

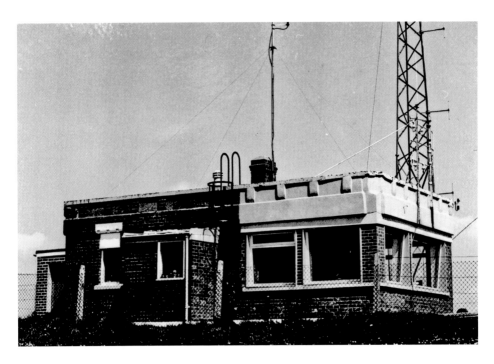

The Coastguard Station at Rame

The coastguard station was originally a Lloyds Signal Station and it would communicate with passing ships using flags during the day and lights during the night. It became a radio station in 1905 and a coastguard station in 1925. Today it is run by Coastwatch.

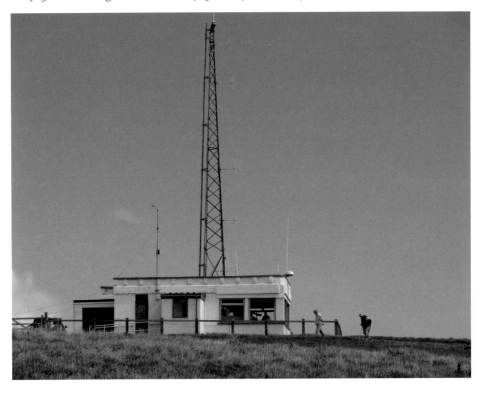

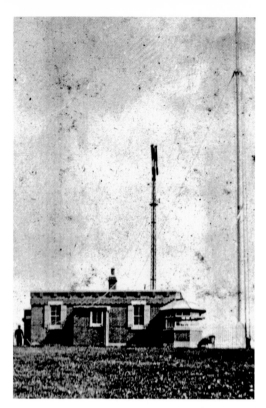

The View from the Coastguard Station

The first photograph shows an older view of the coastguard station at Rame Head complete with communications mast. The coastguard can be seen stood beside the buiding. The later photograph shows the wonderful view from the station looking out over green fields towards Whitsand Bay.

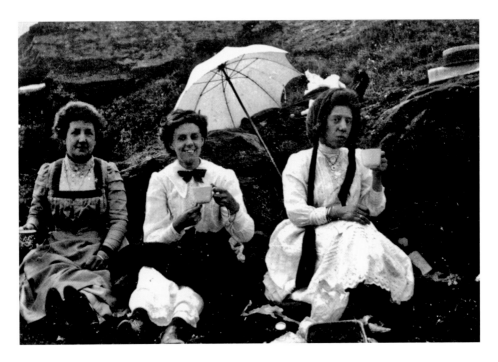

A Picnic at Rame

Three ladies, complete with china cups, have a picnic just below the summit at Rame Head. All are smartly dressed and one has very long hair. The later photograph shows St Michael's Chapel at Rame Head. Hermits lived at the ancient chapel of St Michael and kept a light burning to warn ships of the danger of the nearby rocks. The first record of the chapel appears in 1397.

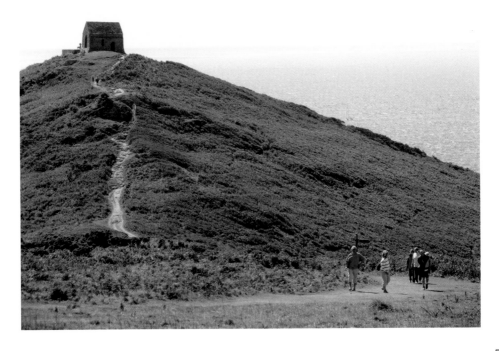

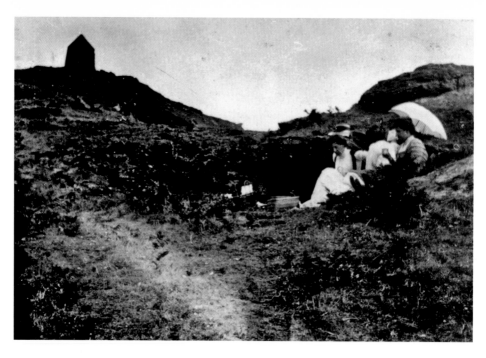

Beneath St Michael's Chapel

The same ladies can be seen in the older photograph and St Michael's Chapel can be seen in the background. This landscape looks exactly the same today. The later view shows the approach to Rame Head from the nearby cliff walk.

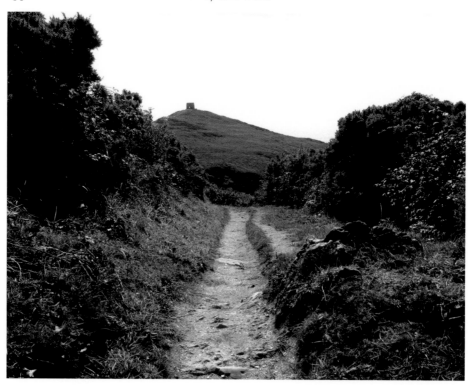

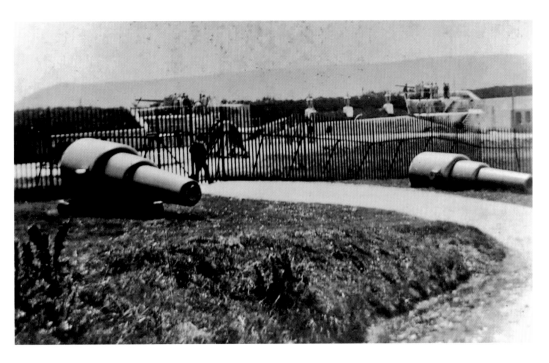

Maker Battery

Built in 1887, Maker Battery formed part of Plymouth's coastal defence. Its guns were removed between 1908 and 1911. Today the whole area is very overgrown and seems to be used by fisherman as a place to store their boats and lobster pots.

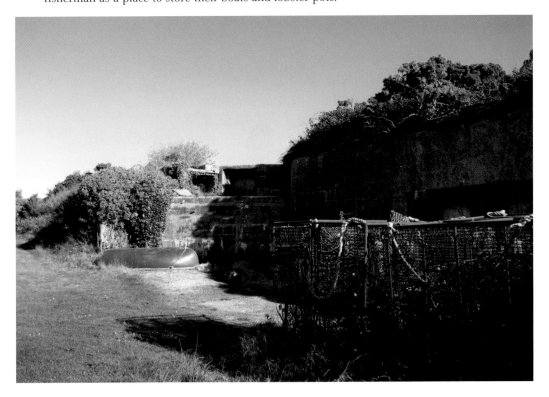

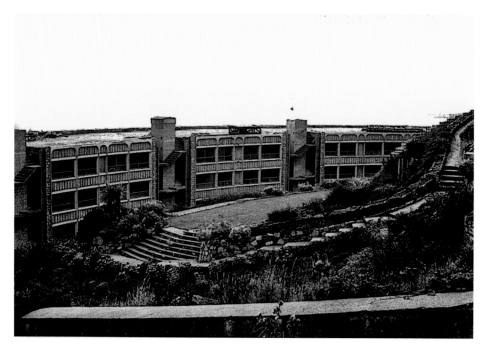

Fort Picklecombe

Fort Picklecombe was originally built as a costal defence between 1864 and 1871. Its guns were removed in the 1920s but were reactivated at the start of the Second World War. After the war, the building stood derelict for many years but it was bought in the 1970s and converted into residential apartments.

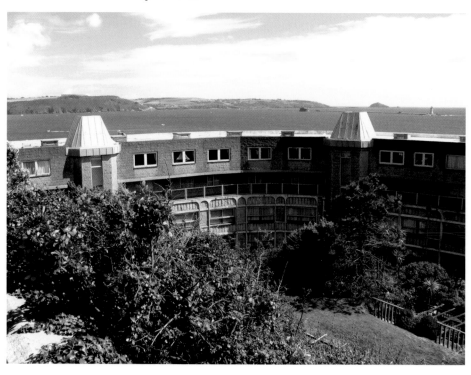

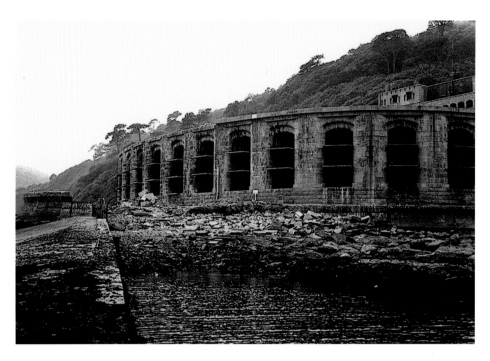

A Derelict Fort Picklecombe

The older photograph shows the condition the fort was in for many years after the war. It has always been prone to severe weather and at times high waves crash against the building. The newer photograph shows the building as it is today complete with windows, balconies and a magnificent sea view.

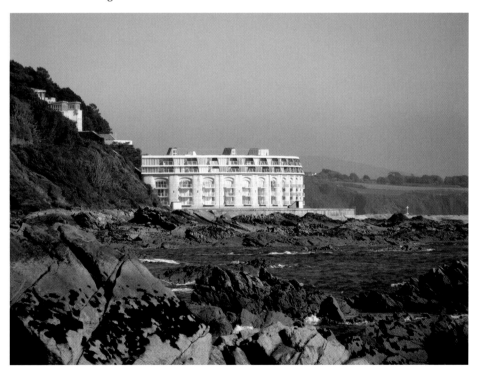

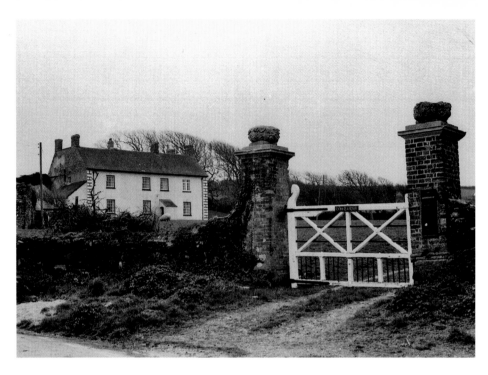

The Farm at Rame Barton

Rame Barton is an eighteenth-century listed farmhouse. It all looks much the same today although the gate posts have been knocked around a bit over the years and the Royal Mail postbox has long since disappeared. Today, it is a very popular bed and breakfast establishment.

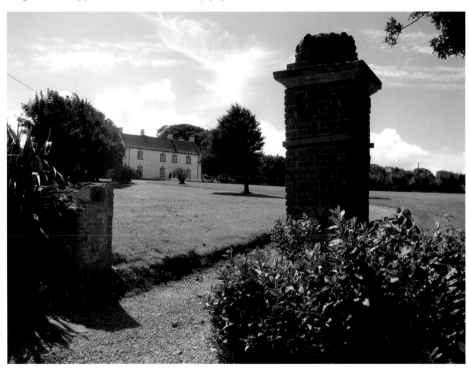

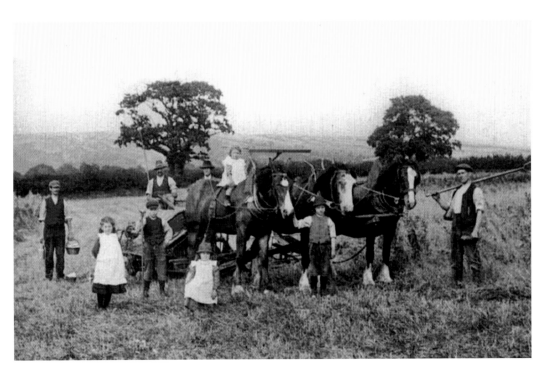

Farming at Rame
The older photograph shows a family farming at Rame. It looks like everybody had a job to do and the three horses would have been kept very busy. There would have been early morning starts for everyone and the children would have probably all helped out as well. Today, the work is made a lot easier with modern machinery, tools and better transport.

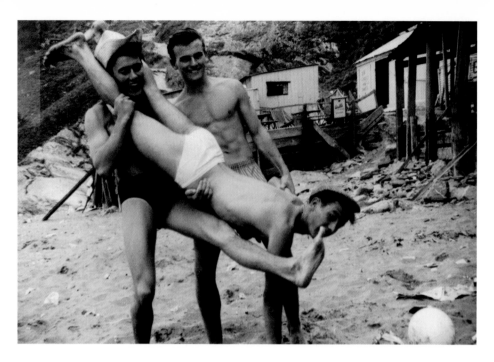

Messing about on the Beach

The older photograph shows Dicky King, John Cole and Trevor Mildren larking about on the main beach at Whitsands in about 1960. The café and buildings in the background are now long gone but the beach is just as popular today and gets very crowded, especially during the summer months.

The Grotto at Sharrow Point

The grotto was built in 1784 by an ex-Naval purser called James Lugger. The exercise was undertaken because he felt that it would occupy his spare time and also help rid him of gout. He carved a poem on the walls and later added an extra couple of lines to say that his gout was cured.

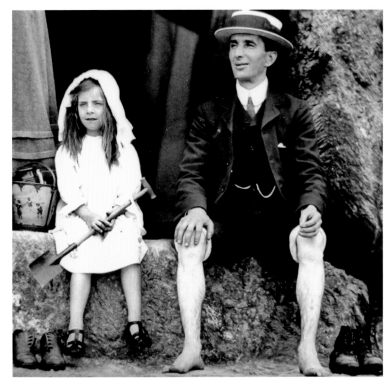

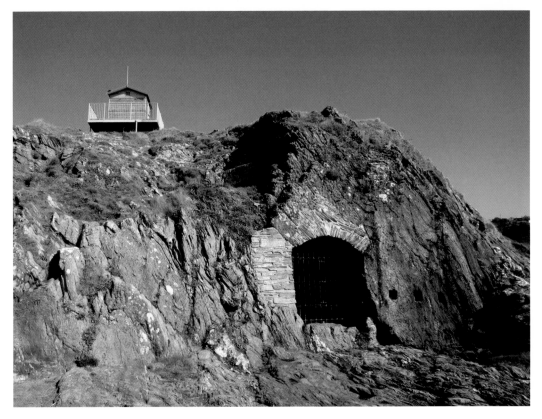

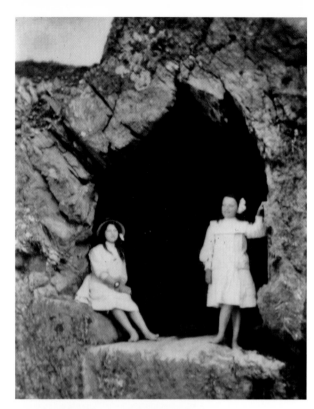

**The View from the Grotto
towards Rame Head**
The ceiling has now collapsed
within the grotto and bars stop
people from entering. It has been
many years since it was last open
and it looks like it is unlikely
ever to be repaired. Today, many
people walk straight by the grotto
without realising it is there. The
path towards the beach cuts right
behind it.

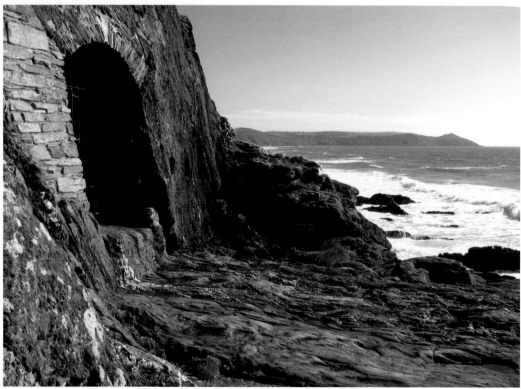

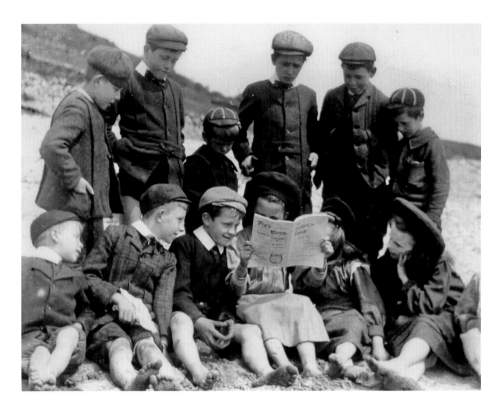

Whitsand Bay

The older photograph shows a group of Victorian children happily reading a booklet called *The Foreign Field*. People were once happy just paddling or digging and building sandcastles. Today, beach activities have changed greatly and there are now many surfers, kite surfers, windsurfers and hang gliders.

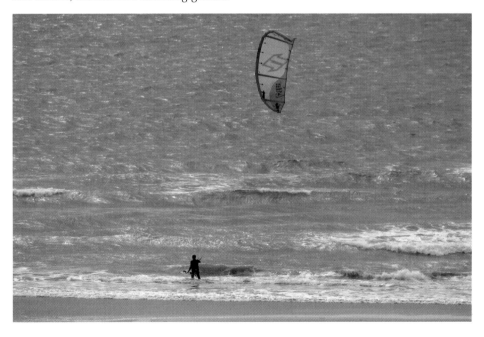

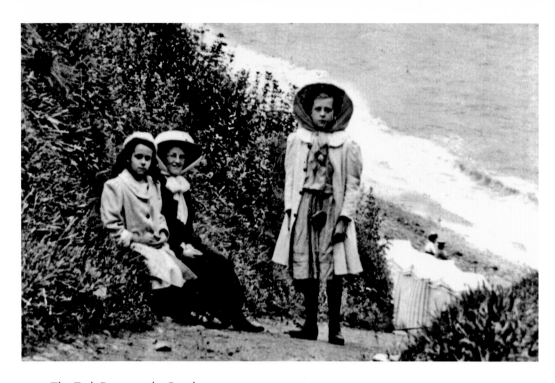

The Trek Down to the Beach

Three people make their way down the steep incline towards the beach at Whitsands. In the background can be seen white changing tents. The newer photograph shows a surfer, complete with wetsuit and surfboard, heading towards the sea.

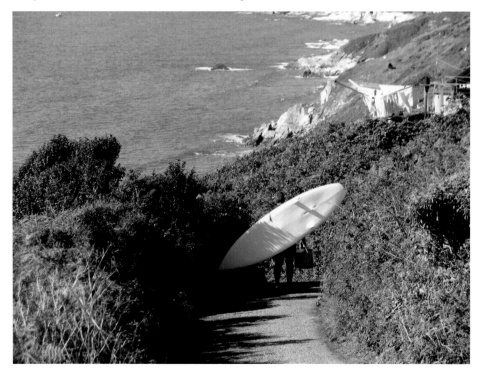

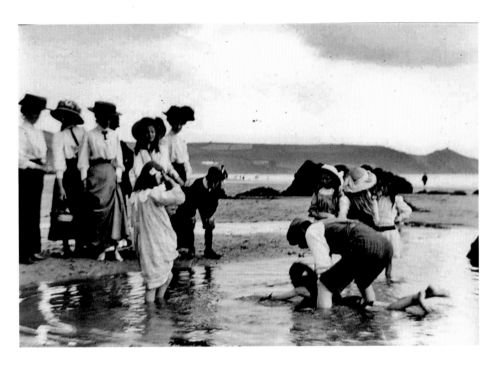

Learning to Swim

The top photograph shows a man dressed in flat cap, trousers, waistcoat and braces teaching a young girl how to swim in a shallow pool at Whitsands. A crowd of people have gathered around to watch. Rame Head can be seen in the background. Today, a busy café stands nearby and many people arrive daily to go surfing.

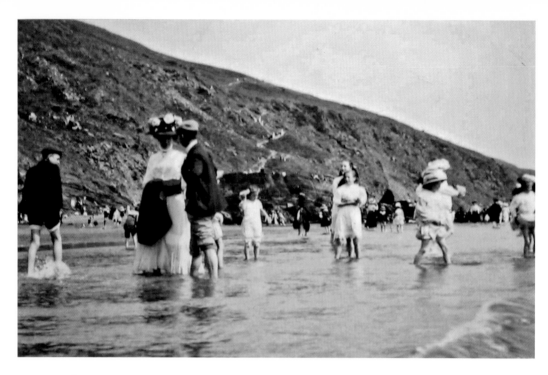

Paddling at Whitsands

The older photograph shows that many people didn't bring swimsuits to the beach or go swimming but were happy with just a paddle along the shore. The men would roll their trousers up but make sure that everything else stayed in place especially their cloth caps.

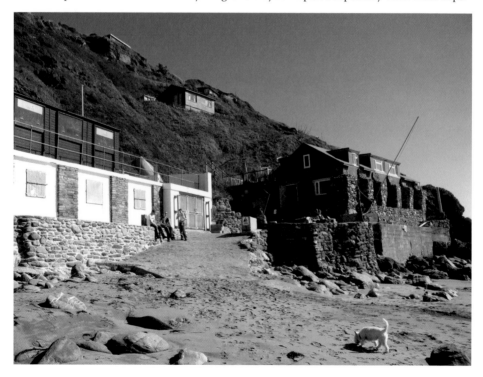

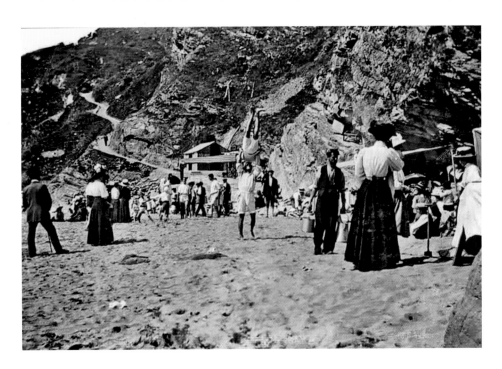

Fun at Whitsands

The top photograph shows a very busy beach. Two men are doing acrobatics in the middle of the picture and one is lifting the other above his head. There are many children enjoying the day out. Some are sheltering from the sun under canvas and parasols. The path to the top looks very steep and it must have been quite a job getting everything down to the beach.

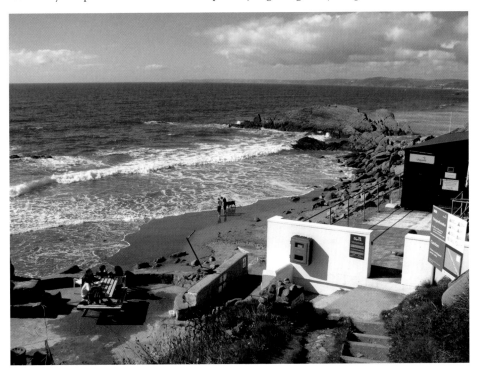

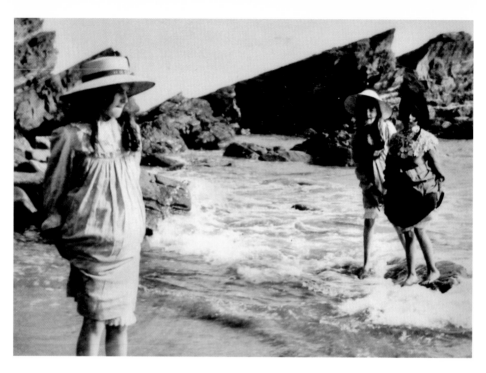

Cool Waters at Whitsands

Three girls enjoy a paddle at Whitsands in the older photograph. The sloping jagged rocks are a feature of the beach. Much remains the same today and the beach still gets very busy, although the later photograph shows it empty on a sunny day in October.

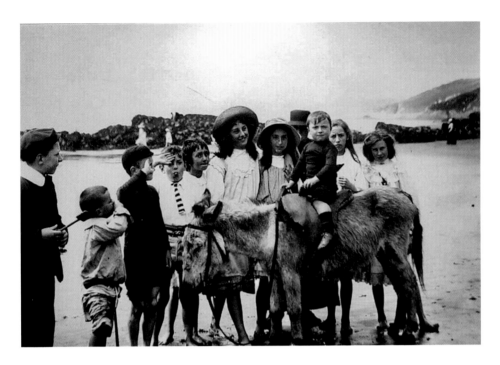

Donkeys on the Beach

It's hard to imagine that there were once donkeys on the beaches at Whitsands. In the older image children enjoy a ride on one as they all pose to have their photograph taken. It would have been quite a trek down to the beach with a donkey and the animal was probably worn out long before it had to give rides to children.

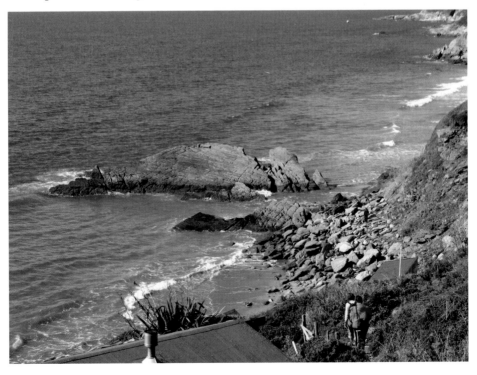

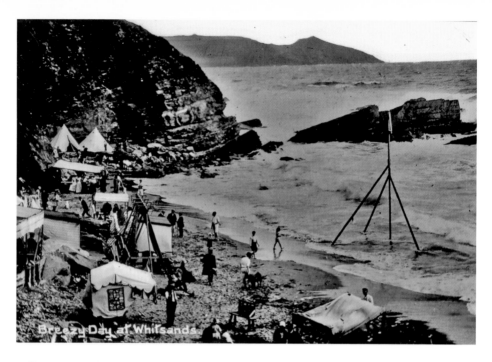

Breezy Day at Whitsands

Bell Tents at Whitsands

As well as many tents, there is also a large group of wooden swings featured in the older photograph. Most people seem content with just being at the beach without actually going for a swim and very few have gone as far as taking their hats off. There are lots of canvas shelters to keep the sun off people although it looks like quite a chilly day.